Creative Watercolor Techniques

Creative Watercolor Techniques

By Zoltan Szabo

WATSON-GUPTILL PUBLICATIONS/NEW YORK

PITMAN PUBLISHING/LONDON

GENERAL PUBLISHING/TORONTO

Copyright© 1974 by Watson-Guptill Publications

First published 1974 in the United States by Watson-Guptill Publications,
a division of Billboard Publications, Inc.,
One Astor Plaza, New York, N.Y. 10036

Published simultaneously in Great Britain by Sir Isaac Pitman & Sons Ltd.,
39 Parker Street, Kingsway, London WC2B 5PB
ISBN 0-273-00812-9

Published in Canada 1974 by General Publishing Company Ltd.,
30 Lesmill Road, Don Mills, Ontario
ISBN 0-7736-0033-7

Manufactured in U.S.A.

Library of Congress Cataloging in Publication Data
Szabo, Zoltan, 1928–
 Creative watercolor techniques.
 1. Water-color painting—Technique. I. Title.
ND2420.S92 751.4'22 73-22234
ISBN 0-8230-1119-4

First Printing, 1974

As we dream, our subconscious mind borrows images from real experiences. When an artist paints, he channels his dreams to flow back into reality through his brush and become a work of art. This transfer is part of a creative process that an artist must recognize, respect, and utilize.

When I dream, I dream of nature. I try to paint nature as I dream it. When each painting is born, another dream comes true. I invite you, my fellow dreamers, to share my dreams—and I dedicate this book to you.

Acknowledgments

My most sincere gratitude to the Audio Visual Department of Sault College, and to Neil MacEwan, for their far-reaching cooperation involving photography essential to the completion of this book. And to all my friends who encouraged and helped me through the problem months of production, particularly Nadean Leonard and Wendon Blake, many, many thanks.

Contents

Introduction

The word *watercolor* implies any painting medium which is soluble in water. For example, transparent watercolor (as perfected by the British), opaque watercolor or gouache, casein tempera, egg tempera and even acrylic all dissolve in water. In this book I have dealt with various media, using other than the traditional methods usually associated with watercolors. However, all such unconventional approaches still share one watercolor characteristic in common—spontaneity. They are all quite fun to do and require an open and curious mind.

The variety of effects achieved with these paints is virtually limitless. You can use them separately, mix them before or during application, or overpaint with them. In fact, you can do anything with them that your imagination may demand! The behavior of these paints is influenced by their environment, as well as by your personality. These factors include the air temperature while you work, the humidity, the proportion of moisture mixed into each brushful of paint, and your working surface.

It doesn't matter how well you master the technique of watercolor, you can never be sure if your next painting will be a fresh work of art or a spoiled mess. The temperament of these aquatic media (as all watercolors are called), guarantees the final result will always be as unpredictable as it is challenging. The constant battle between painter and media offers an exciting reward for a persistent artist: a successful painting. Never let the ruined attempts lower your morale. Remember that your learn every time you paint. When a watercolorist is hooked, he is hooked for life—for a very exciting life!

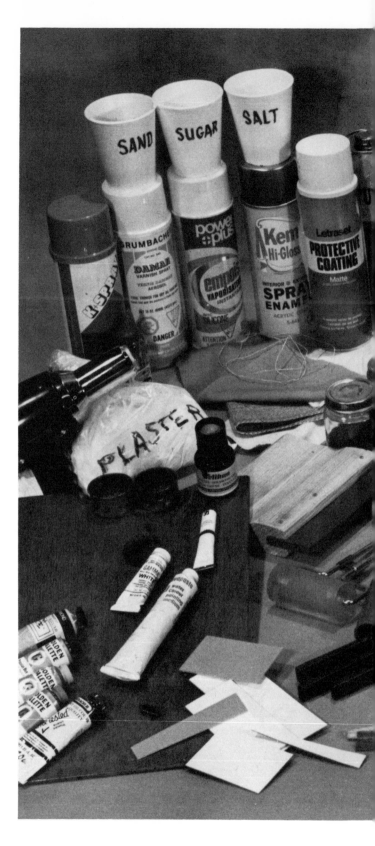

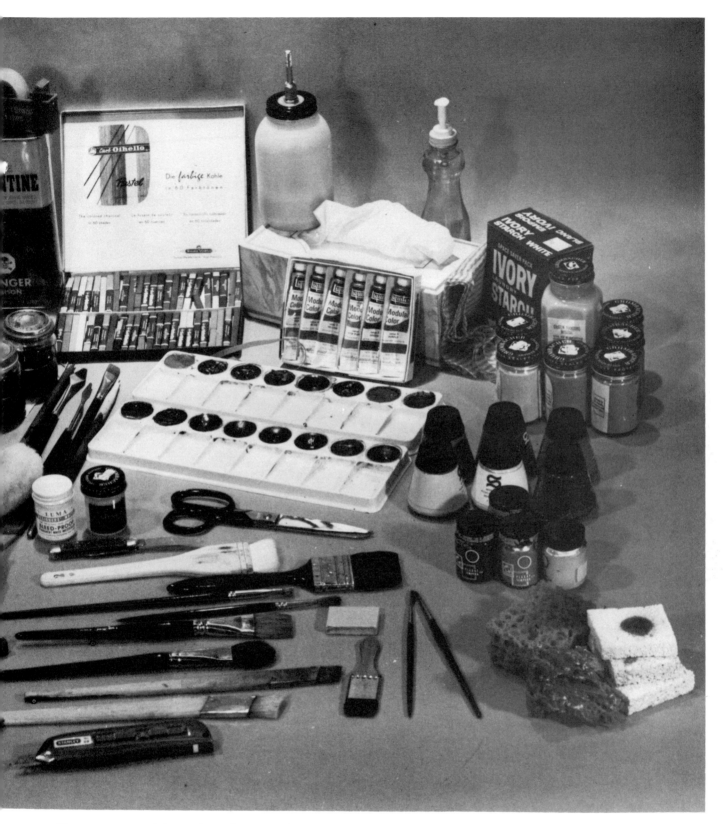

Here are some of the tools and materials you might use to improvise your own watercolor techniques. Later, in each chapter, I will give you further details on specific papers, brushes, and paints.

1. Starting with a Deliberate Accident

The accidental approach to watercolor painting is particularly useful when you're in a hesitant mood, when you're eager to paint but can't decide on a subject or approach. Your brushes, paint, and water are ready to go and soft music purrs in your ears, putting you in a creative mood. Then, a glaringly clean sheet of your favorite paper stares up at you and whispers, "Don't you dare touch me. I am immaculate and beautiful. Why don't you go and watch TV instead?" When this happens, it's time for action.

Materials

1. Your usual tubes of transparent watercolors.

2. Watercolor brushes.

3. Handmade watercolor paper.

4. A piece of flat cardboard or wood.

In addition, you'll need ideal studio conditions: I strongly advise you to allow no distractions; total concentration is necessary to do a good job.

You have to create an element of accident in order to stimulate a fresh, new approach. Any unintentional start will be helpful. The following examples illustrate how this can be done.

"Accidental" Printing

Select a piece of board with a smooth surface; cardboard, wood, or even a sheet of paper will do the job. Apply a few quick blobs or brushstrokes of your favorite color to the surface of the board. Before the paint has a chance to dry, turn the board over so that the painted side touches and transfers some of the paint to the surface of your watercolor paper. To make the transposed image still more "accidental," move the board around in a haphazard manner while it's still in contact with the surface of the paper. Then lift the board and look at the outcome (A). The resulting abstract smear may look like a mess at first glance, but try to relate it to something meaningful, as you do when you discover familiar objects while looking at clouds. You can repeat this procedure until an idea clicks. As soon as you see a possibility, develop it into a finished painting.

A. ACCIDENTAL BLOB

B. BLIND BRUSHSTROKE

"Blind" Brushstrokes

Make a few brushstrokes on your paper in complete darkness. Don't try to make your mark resemble anything, just let your hand go free for a few seconds (B). Turn the light back on and look for an idea; when you find one, complete your painting.

C. WET TISSUE

D. BEADS OF PAINT

Rolling Wet Tissue

You can start another way by making a small ball of wet facial tissue and saturating it with watercolor. Place this wet ball on your paper and roll it back and forth by tilting the paper in different directions. The resulting line pattern can be exaggerated if you use several balls, separately or simultaneously, saturated with varying colors (C).

Beads of Paint

Splash a heavily overloaded brushful of pigment onto your paper to create a deep pool of paint. Blow hard at this puddle at close range until a little bead of paint starts running away. Blow in several directions until the blob of paint takes on an interesting form. You'll add interest if you do this several times, using different colors and making them partially overlap some of the earlier shapes (D). Try adding new colors while the previous ones are still wet, or let each puddle dry before introducing a new one.

Another Approach

The sequence E–H shows yet another approach. First, I wet my paper (300 lb., medium-rough) because wet paper makes accidents even more unpredictable and exciting (E). I load my 1″ flat brush with one of my favorite colors, warm sepia. I hold the loaded brush about 10″ above my paper and pinch the bristles so that the paint splashes onto the wet surface of the paper. The paint starts to spread rapidly. The abstract shapes remind me of clusters of weeds; since I love weeds and grass, I'll pursue the suggestions of my accident.

I add a few more splashes of related warm colors and tilt the paper to force the wet paint to flow in a direction that complements the composition being shaped (F). When the wet paint begins to spread more slowly, I use a bunched-up tissue to wipe off the excess water that has accumulated on the edges of the paper. For the following strokes, I use more paint and less water in my slanted bristle brush. These strokes remain soft but begin to keep their form. I continue with this approach, avoiding mechanical symmetry and building my composition a little further with each touch.

After the shiny, wet surface of the paper begins to dry and turns dull, I reach for my small painting knife and squeeze the slim strokes of paint off the damp paper with a firm motion like that used to spread butter (G). These light strokes represent light, sharp weeds among the dark, soft ones.

I add the final sharp details after the paper is completely dry (H).

E. PAINT SPLASHES

F. DIRECTING THE FLOW

G. SCRAPING WITH A KNIFE

H. ADDING DETAILS

Starting with a Deliberate Accident

Step 1. (300 lb. D'Arche's cold-pressed handmade paper.) I make an impression with a richly loaded natural sponge by vigorously pressing it on dry paper.

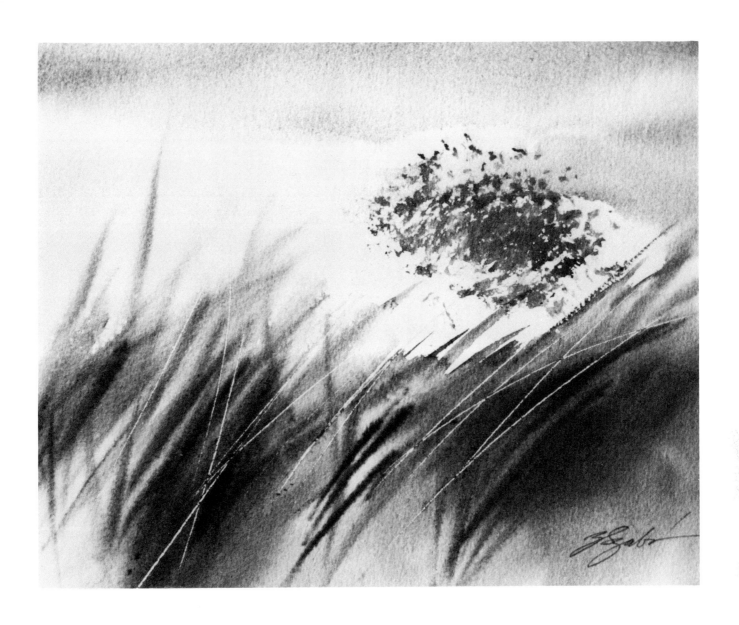

Step 2. Avoiding the sponge mark, I wet the surrounding space. Using a soft 1″ brush, I sweep gentle blue washes on the top area. With a bristle brush, I apply the mass value of weeds at the bottom. A few scrapes with a pocketknife point on the damp paper supply some details.

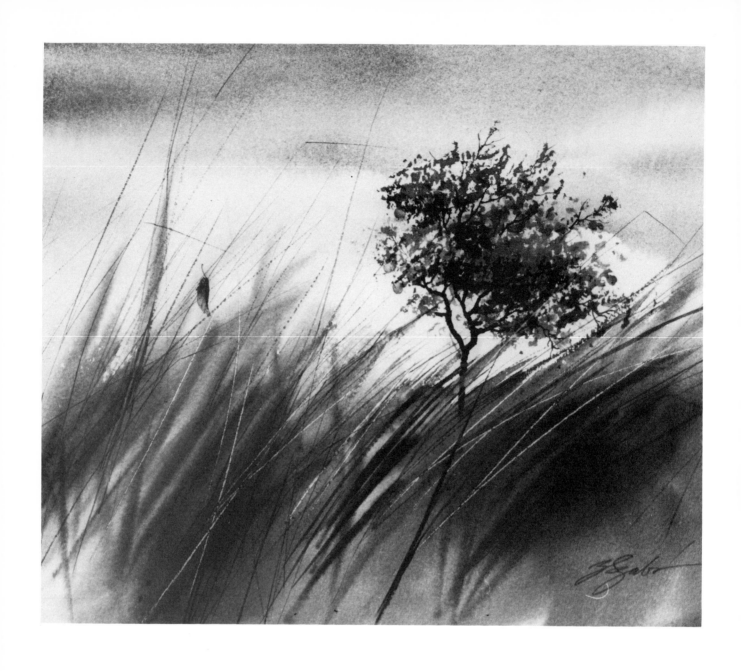

Step 3. I add a few darker sponge impressions and turn the circular sponge mark into a tree shape. A few branches and apples on the tree as well as fine lines hinting of loose weeds complete the mood. The little leaf caught in the weeds adds final interest to the composition.

2. Painting on Wet Paper

Seeing watercolor respond to wet paper is one of the most thrilling experiences a painter can have. This process of applying wet watercolors to wet paper is sometimes called the wet-in-wet technique. Because you must work quickly to apply your washes before the paper dries, this technique will certainly help you loosen up in your work. I hope you have exciting results when you try it.

Materials

1. Two large containers of water: one with clear water used only for wetting the paper and clean brushes, the other with water in which to clean your brushes.

2. A fist-size sponge and lots of paper towels or tissues with "wet strength" to grab as you paint.

3. Brushes: a large, soft, flat brush at least 2" wide; a 1" flat brush; and your other favorite watercolor brushes.

4. Handmade watercolor paper.

5. A palette of your usual transparent, tube watercolor paints.

Because so many different types and qualities of watercolor paper are available (machine-made as well as handmade), and because working conditions include virtually unlimited variations in air temperature and humidity, it is impossible to set out firm rules for using the wet-in-wet technique. Your own experience is the only guide you can depend on. However, the following are several factors you should keep in mind as you make your first attempts.

Outdoor Working Conditions

As the minutes go by, the surface of your wet paper will change; it will absorb some of the water as the excess starts to evaporate. The rate of drying will depend on the temperature and the amount of humidity in the air. On a cold day when temperature is around the 35° mark, your drying period will be so long that you may have to speed it up by artificial means—for example, by placing your paper near your car heater. Dry, hot air, on the other hand, will speed up the evaporation process.

You should never paint in direct sunlight; the drying will be instantaneous, and the blinding glare from your paper will distort your value and color judgment. Find shade, or turn so that the sun is behind you and your body creates the necessary shadow.

Extreme outdoor conditions are the exception rather than the rule. However, if the elements prevent you from painting wet-in-wet on location, use another approach; do your wet painting later, in your studio where you have more control over atmospheric conditions.

Horizontal Painting Surface

The law of gravity effects the behavior of watercolor on wet paper. If you place your shiny wet paper on a horizontal surface—a table, for instance—the watercolor paint will spread evenly in all directions as soon as you apply it (A). Gravity forces the excess water in the paint to spread and combine with the water on your paper.

Tilted Painting Surface

If you tilt your wet painting surface in any direction—either before, while, or immediately after you apply paint—the paint will rapidly flow downward as the result of gravity (B). The steeper the slope of the paper, the faster the paint will flow. You can control the flow of the paint by rotating your paper either clockwise or counterclockwise as you hold it at the same angle.

Diluted Paint

The degree of definition your brushstrokes have when applied to wet paper is also effected by gravity. Even though you may not be conscious of the reason, the result will be obvious. The thinner the paint on your brush, the further it will spread as you apply it (C). Consequently, the less diluted the paint, the less it will spread and the more definition it will have.

Accidental Scratching

When watercolor paper is wet, its surface is easy to mark, either accidentally or on purpose. Such marks

A. WATERCOLOR ON WET PAPER

B. TILTED SURFACE

C. LIGHT AND HEAVY WASHES

D. ACCIDENTAL SCRATCHING

E. CREATIVE SCRATCHING

F. RE-WET AND RETOUCHED

are permanent and cannot be corrected or removed. Your fingernail can leave a scratch that will ruin a painting. When a sharp object scratches the wet paper, it tears the smooth surface. The paper along this damaged line acts like a soft blotter, absorbing water faster than the untouched surface areas. During the process, an extra amount of pigment is trapped in the damaged area, making the line appear darker than the washes around it (D).

Creative Scratching

Scratching wet paper is actually another creative technique; you can use the sharp point of your brush handle to draw on the wet surface of the paper. Whether you do your drawing right after wetting the paper with clean water and apply paint over it or first apply a color wash and then scrape your lines in, the result will be the same (E). The latter method is safer, because it allows you to see your dark lines instantly and therefore have more control over your composition. Remember, however, that the lines can't be erased.

Retouching a Dry Painting

The greatest advantage of using the wet-in-wet technique is its resulting looseness and freshness. You should try to discipline yourself to work at the appropriate speed for the drying time of your paper, so that you can make all the necessary brushstrokes while the paint is still wet. However, if the paper should get ahead of you and dry before you've finished, put down your brush and wait until the painting dries completely. Then use a soft, wide brush to re-wet an area at least three times as large as the area you want to cover with your brushstroke. This re-wetting must be done with a clean brush, clear water, and in one sure sweep over the painted area. Don't try to apply two strokes or you'll smear the moist pigment that your first wet touch has already loosened up. Onto this newly wet spot, paint your missing brushstroke just as if the whole surface were wet. In illustration F, the area of cloud in the left center was an afterthought; I added it using the procedure just described.

Painting on Wet Paper

Step 1. (300 lb. D'Arche's cold-pressed handmade paper.) A quick sweep with a soft, wide brush establishes the edge of the hill and a hint of the misty sky. I use a bristle brush well loaded with pigment on the saturated paper surface to indicate the misty forest at the edge of the hill.

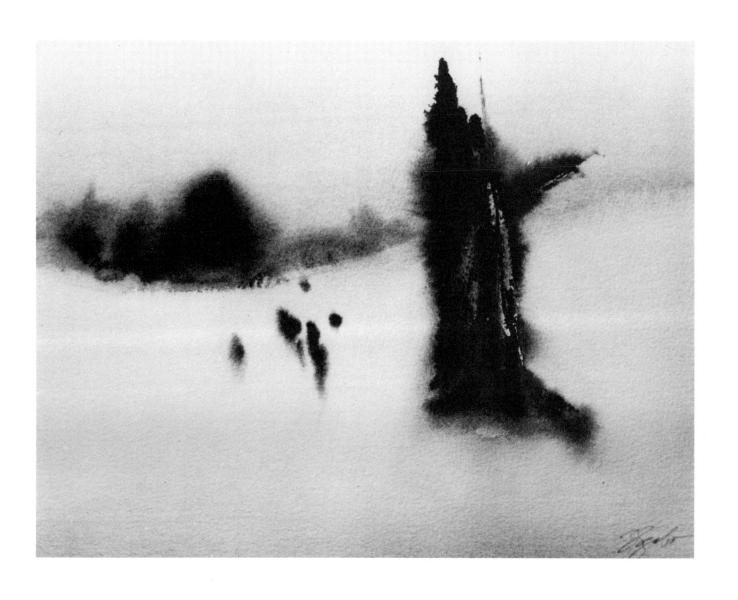

Step 2. While the paper is still wet, I brush in the warm colors of the stump and the fuzzy weed seedlings. As the paper loses its shine, I begin to paint crisp details onto the stump.

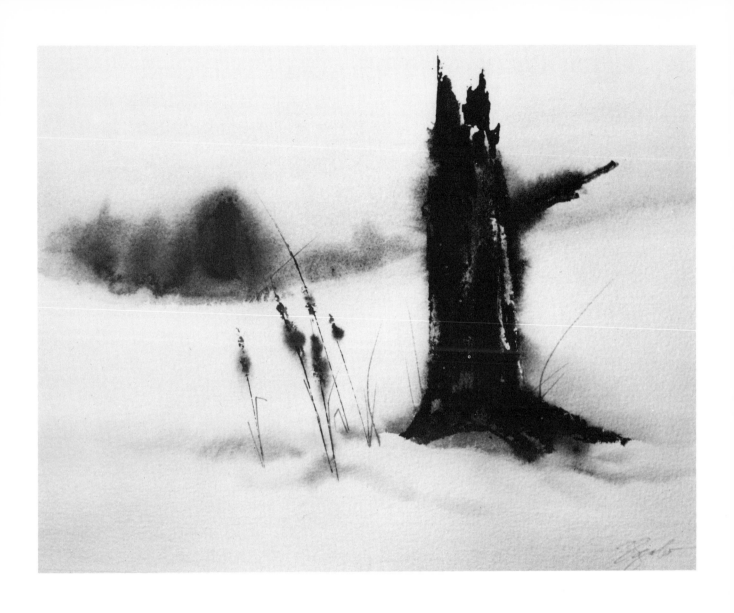

Step 3. I continue to paint the crisp details, here in the stems of the weeds. I re-wet the area at the bottom of the weeds with a single, quick pass of a soft, wide brush loaded with clean water. While the paper is wet, I paint blue hints of snow "dimples" at the base of the weeds and at the foot of the stump. After this dries, a few fine brushstrokes showing leaves on the weeds finish the job.

3. Graphite Wash Technique

One disadvantage of watercolor is that it can't be used outdoors in cold weather. Water freezes; consequently, watercolor freezes on your paper as you apply it. To paint in watercolor the lovely landscape subjects winter offers, you must paint indoors from references. However, the techniques involved in using graphite washes are the closest I've found to those of watercolor, and graphite washes won't freeze even in sub-zero temperatures.

Graphite washes will give you tones and textures characteristic of watercolor, but in only one hue—gray. In a sense, such paintings have the same reference value as pencil drawings, except that they also offer the subtle tones and watercolor characteristics that pencil drawings can't duplicate. Because of the incredibly fast drying quality of the solvents used, you should keep your graphite-wash sketches small. On large surfaces, work on one small area at a time and move from one area to the next.

Materials

1. A sheet of very fine sandpaper.

2. 2H, 2B, and 6B graphite pencils (these are ordinary writing pencils, which are often mistakenly called "lead" pencils).

3. 2H, 2B, and 6B flat graphite drawing sticks (these come in 3″ x ½″ x ¼″ pieces).

4. A flat, 1″ watercolor brush, and a firm, short-haired bristle brush.

5. A pint of turpentine, benzol or benzine solvent and a small metal dish to hold it (don't use plastic, because the solvent will dissolve it); I prefer to use turpentine because it dries a bit more slowly than benzol.

6. Any high-quality, smooth drawing paper. If you want the color of the paper to remain permanent, buy a paper with a 100% rag content. Pulp papers are cheaper, but they turn brown with age. Your painting procedure will be the same, regardless of the type of paper you use.

Turpentine, benzol, and benzine liquify graphite, but the latter two are *highly toxic and extremely flammable*. Use them only outdoors. Do not smoke or use fire or sparks anywhere near your working area. The fumes of either solvent can ignite very easily. Remember: Using graphite washes is an *outdoor process*, so use them *only outdoors*.

When you're ready to begin painting, pour about an ounce of solvent into the metal dish, tray, or similar utensil.

Using Graphite Sticks

Dip your brush into the solvent and rub it on the 2H graphite stick until the brush is loaded with the dissolved graphite mixture. Transfer the mixture onto your paper in one or two brushstrokes. Repeat this procedure with the 2B and the 6B sticks as well. You'll notice that your brushstrokes look like gray watercolor brushstrokes (A). The softer the graphite stick you use, the darker the brushstroke will be. Don't be upset if the solvent evaporates almost instantly. You have to act fast to keep pace with the drying time when you use graphite washes.

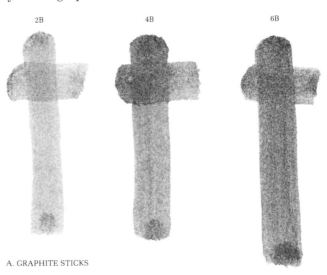

A. GRAPHITE STICKS

Using Graphite Dust

If you can't get graphite sticks, or if you want very rich washes, use the sandpaper-and-pencil method. Fasten a 4″ x 9″ piece of fine sandpaper to a hard, smooth surface to keep it from sliding around. Draw a wide line with each of your three pencils as if you were sharp-

2B

4B

6B

B. GRAPHITE DUST

ening their points. Keep your lines separate from one another. Then use the accumulated piles of graphite dust to mix your gray washes, just as you used the sticks (B). The advantage of using this method is that you can pick up the graphite more quickly, making your mixture before the solvent has a chance to dry on your brush.

Wet-in-wet Using Solvent

You can achieve the subtle effects of wet-in-wet painting by slapping a generous wash of solvent on to your paper and immediately applying graphite washes to it (C). Manipulate your brush as if you were working with watercolor, but work much faster. If the solvent dries too fast on your brush, just dip it back into your tray and continue painting. You can blend and smooth out your darks by applying more solvent, making changes until your sketch has all the subtle tones you want. If you use a firm bristle brush, it will give you a strong gray tone; using a softer brush will result in lighter brushstrokes.

After you complete a graphite-wash sketch, you can create accents by using a graphite pencil to add sharper finishing touches (D). However, try not to overwork your sketch; preserve the soft look of the washes at any cost.

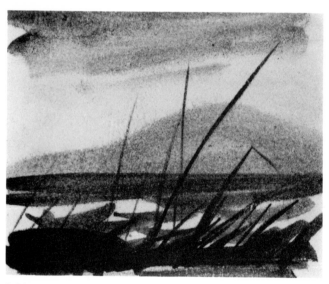

C. SOLVENT WASH

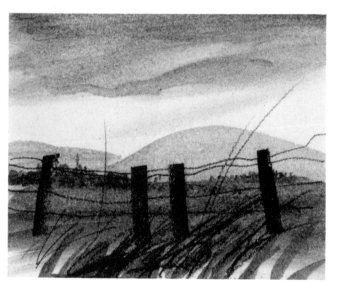

D. GRAPHITE PENCIL DETAILS

Graphite Wash Technique

Step 1. (300 lb. D'Arche's cold-pressed handmade paper.) First, using a bristle brush, I saturate the paper with a solution of 4-B graphite and turpentine. Next, I wash in the sky, using vigorous horizontal brushstrokes. Onto the drying surface, with more graphite and less turpentine on the brush, I paint the distant island and its faint reflection. A hint of the rocky shore and of water in the foreground complete my preliminary sketch.

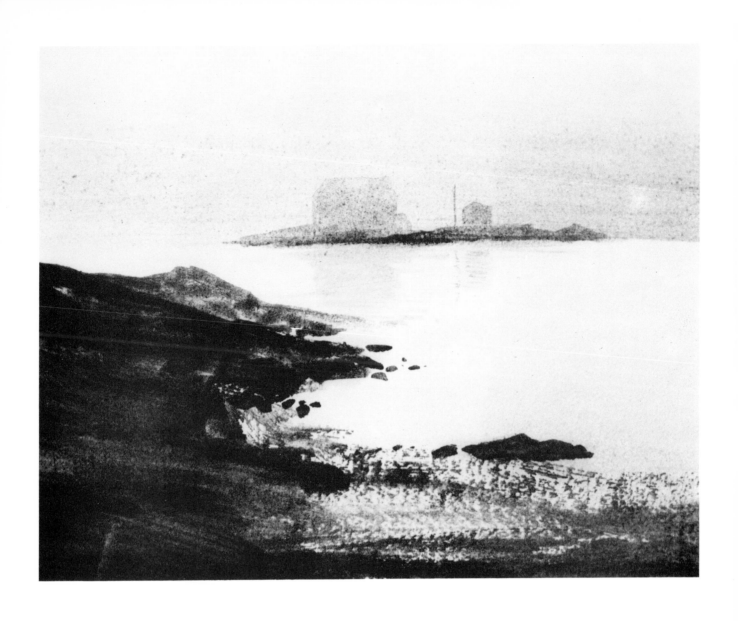

Step 2. Still using a bristle brush, I elongate the island and add the smaller hut, the telephone pole, and their reflections to help balance the composition. Then, using a bristle brush richly loaded with a solution of 6-B graphite and turpentine, I stroke on the sloping shoreline and a few rocks in the shallows. I indicate the gravel beach with a few drybrush strokes.

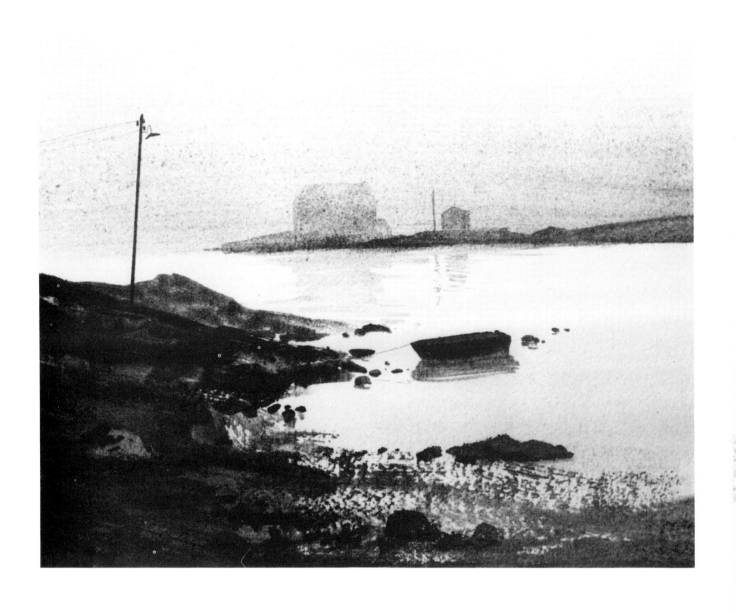

Step 3. For the finishing touches, I add a few boulders to the shore, the boat, and its reflection, and a lightpost.

4. Using Opaque Watercolor

Opaque watercolor, also known as designers' colors and gouache, is sold in jars, in individual tubes, and in sets of tubes packed in metal boxes. The behavior of opaque colors is similar to that of transparent colors. Because they're both soluble in water, transparent and opaque watercolors can be called "sister" mediums. Opaque colors are usually made of the same pigments as transparent colors, with the same gum medium as binder. To render them opaque, the manufacturer adds chalk or Chinese white, both of which tend to make opaque colors somewhat chalky. When thickly applied, light opaque colors are capable of covering dark ones completely.

Materials

1. Your regular watercolor brushes will work very well with opaque watercolors.

2. A high-quality white in your palette of opaque colors, preferably titanium white, which mixes well with any color without dirtying the color.

3. A white palette or a plain white porcelain plate to serve as a mixing surface.

4. Lots of scrap paper to test your paint on.

5. A generous container of water.

6. Tissues.

7. A small cake of any soap to clean your brushes after your use them.

Opaque pigments are quite stubborn to clean out of brushes, and soap is necessary to do a good job. Any paper will do as a painting surface, but a high-quality paper will give you the best results. Now let's explore the characteristics of this opaque medium.

Adding White and Black to Opaque Colors

The only time you should use water with opaque watercolor is when you want to thin the paint as it comes from the tube—and then you should be careful not to dilute your colors so much that they become transparent. To raise the value or lower the intensity of an opaque color, you should use white paint rather than water. For example, if you add white paint to a strong red, you can raise the value of the red—create a paler tint of the same color—as well as lower its intensity.

The infinite variety of tints and values that can be created by the addition of white paint to opaque colors suggests exciting new painting possibilities. On a foggy day, for example, when there is little contrast of value and colors have relatively low intensity, you can suggest these effects by adding a touch of white to every brushful of pigment you apply, or by using a large, soft brush to quickly slap a white wash over a completed dry sketch.

Like white, black is another color that most artists refuse to use with transparent watercolor, but which is very useful with the opaque medium. It's a good neutralizer—that is, it can be used to equalize value contrasts—and it produces a variety of greens when mixed

with different yellows in various proportions.

Black and white combine to produce a cool, bluish gray. You can warm this gray by adding a touch of yellow ochre or a bit of brown to it. The amount of color you add is crucial, so be very cautious and begin by adding very small amounts.

Try adding a little black and a mixture of black and white to each of your pigments and observe the results. (See Color Chart A on page 81.)

Mixing Light and Dark Opaque Colors

Another property of opaque watercolor shows up when you mix light colors with dark ones. (See Color Chart B on page 81.) The light color will produce the same results as those obtained by adding white—it will raise the value and lower the intensity of the dark color. The resulting wash will be a little chalky, but this is noticeable only when you compare these opaque washes with transparent washes. Experiment by mixing light colors with dark before you apply them to an actual painting.

Drying Characteristics of Opaque Colors

Opaque pigments dry much lighter than they appear when wet (see illustration). Don't be upset about this; simply prepare your colors so that they look a little darker as you apply them and they'll be just right when they dry. With practice, you'll automatically allow for the change.

LEFT SIDE IS WET, RIGHT SIDE DRY

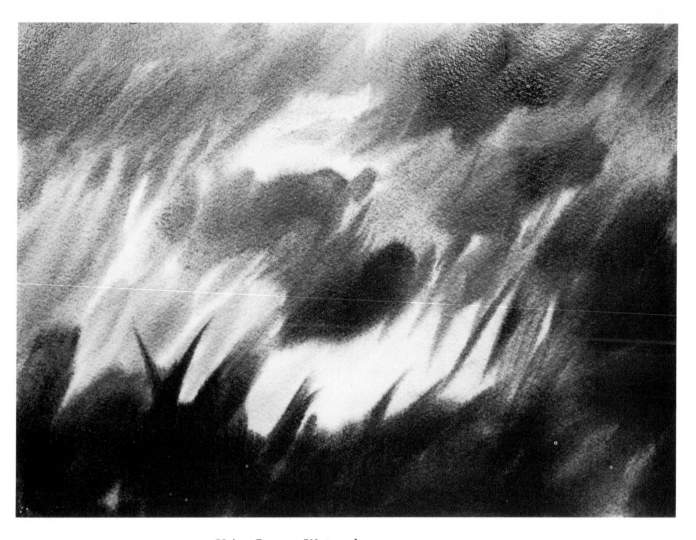

Using Opaque Watercolor

Step 1. (300 lb. D'Arche's cold-pressed handmade paper.) By brushing heavy washes of browns, blues, and greens onto the wet paper surface, I suggest the mass value of tall weeds and establish a background for the weeds to come. At the bottom of the painting I use more blues to indicate early morning shadow.

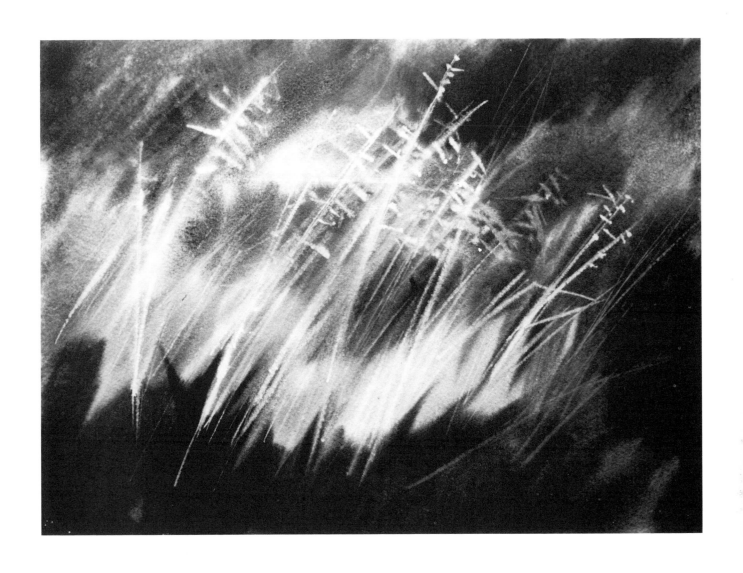

Step 2. While the background is still wet, I use a small sable brush loaded with a heavy consistency of white paint and a touch of yellow to establish the frost-bitten weeds in the foreground. As the paint hits the damp paper and spreads, the frostlike irregularities happen naturally.

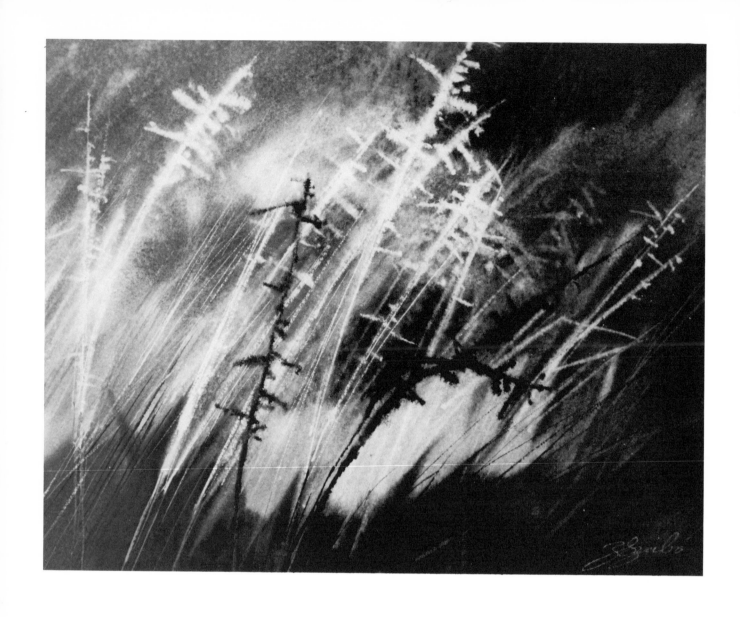

Step 3. Using a thickly loaded, fine brush, I paint the blue-shaded, frost-covered weeds in the foreground of the still-damp paper. When the surface is completely dry, I sketch fine, grassy "whiskers" with light or dark colors to indicate strong light and dry shadow.

5. Using Transparent and Opaque Watercolors Together

To use transparent and opaque watercolors together successfully, you must take advantage of the natural qualities of both. For example, while light transparent colors won't cover dark colors, light opaque colors will. Once you've learned how to use these two very compatible mediums together, I'm sure you'll find many opportunities to combine them creatively.

Materials

1. Any high-quality handmade watercolor paper.

2. Two or three soft, round pointed brushes; a soft flat, 1″ brush; and a small painting knife.

3. One palette for mixing transparent colors and one for mixing opaque colors.

4. Lots of tissues.

5. Two containers of water, one for cleaning brushes and the other to hold only clean water. Keep the water in the second container clean at all times, so that it will be ready to use as you work quickly.

The most natural approach is to start by applying your transparent colors. Don't go back and forth between transparent and opaque colors because you'll drag opaque pigments into your transparent colors, thereby changing their nature somewhat. Proceed with your painting without too much concern about light accents, for which you can use opaque pigments later.

Painting a Distant Forest

Just a simple, slightly varied, dark transparent wash is enough to represent the edge of a forest (A). After this wash dries, you can use opaque colors to apply as many trees as you wish over it (B). For these strokes, dilute your opaque paint with enough water to give it a heavy, sour-cream consistency.

Painting the Interior of a Forest

Let's look at another practical case—the interior of a forest, wtih trees freshly laden with snow. First use transparent watercolor to paint the trees, suggesting the structures of all the branches to indicate the density of the forest. Ignore the fluffy snow on the

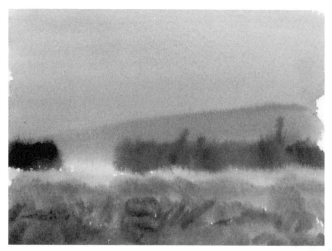

A. TRANSPARENT WASH

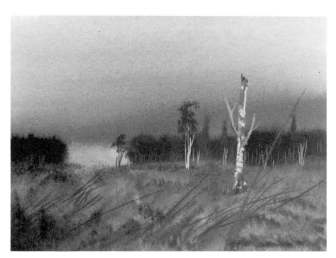

B. OPAQUE OVERPAINTING

branches at this stage. When you're satisfied with the values and design of your transparent painting, and you're sure that the painting is completely dry, you can begin using opaque white to add the snow on the trees. Use a thin white wash for the distant patches, so that the paint will dry slightly transparent and the dark colors beneath will show through just enough to make it a bit darker than pure white. On the closer branches, use

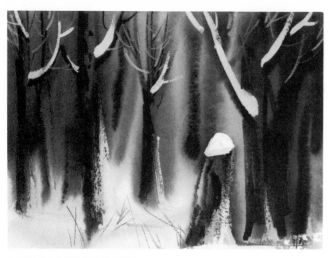

C. TRANSPARENT AND OPAQUE

quick, brave brushstrokes to apply thick white washes, leaving the sparkling areas of drybrush that occur here and there as the paint begins to dry on the brush. Use the same techniques with thin and thick washes for the blown snow at the bases of the distant and closer trees (C).

Adding "Afterthoughts"

It's important to remember that you can apply opaque paint on top of other colors, transparent or opaque.

This means that you can take advantage of after-thoughts. For example, you can paint playing children into a completed landscape or street scene which lacks a strong center of interest, and several freely gliding sea gulls can bring to life a well done watercolor sketch of a seaside fishing village. When painting with opaque colors, you can place such forms wherever your composition needs them, regardless of what colors you have to paint over.

Mixing Transparent and Opaque Paints

Mixing opaque paint into a wet wash of transparent pigment creates unpredictable "oozes," or streaks of opaque paint. The opaque color tends to dominate the transparent wash after it dries, particularly when a light opaque color is added to a darker transparent wash. This is an exciting process that lends itself to fresh "accidents." To avoid dirtying the colors on your palettes when you mix the two mediums, use one brush for the transparent color and another for the opaque paint.

If you want to experiment with this approach try painting a huge sky filled with clouds made from transparent-opaque mixtures.

For the demonstration of *Using Transparent and Opaque Watercolors* see the color plates on pages 82–83.

6. Using Acrylic Paint as Watercolor

The endless possibilities provided by this untamed medium, which can be used both as watercolor and as oil paint, make it easy to fall in love with. In this book, I simply don't have the space to do more than introduce you to the essentials. However, if you wish to learn more about the medium and its uses, I strongly urge you to buy a good book on the subject, such as Wendon Blake's *Acrylic Watercolor Painting*, which I've listed in the Bibliography at the back of this book.

Materials

1. About a dozen tubes of acrylic paint.

2. A plastic, porcelain, or metal palette for mixing paint.

3. A small bottle of retarder to slow down the drying time of the paint.

4. A bottle of acrylic painting medium.

5. A flat, soft, wide bristle or nylon brush; three round sable brushes, each a different size (Nos. 4, 8, and 12 will do).

6. A palette knife.

7. Any high-quality paper, though handmade paper will produce the best results.

8. A fist-size sponge.

Keep an open and receptive mind as you experiment with arcylic painting techniques. The medium is so new that many approaches to it are yet to be discovered, and you may be the one to stumble onto one or more of them.

You can use acrylic paint to create almost all the effects of transparent and opaque watercolor. The following experiments illustrate the many advantages of using acrylic:

I must give you one warning about using this medium: before you touch acrylic paint with your brush, be sure to moisten your brush with water. If you don't, the acrylic emulsion will stick to the dry bristles and will gradually build up a stiff film that will ruin the brush.

Drying Time

Although acrylic paint dries very rapidly, I'd like to dispel the myth that it dries too fast. It doesn't have to. You can now regulate the drying time of acrylic paint by adding a small amount of retarder, which is made specifically for this purpose and is available at artists' supply stores. You should try painting with and without the use of retarder to determine which you prefer.

Overpainting with Acrylic

Acrylic paint is water soluble when wet, but it dries to form a tough, waterproof film. Unlike watercolor, acrylic paint can't be softened with water and then wiped off the painting surface. However, this characteristic will allow you to paint one thin wash over another that has dried completely to create an almost infinite variety of translucent, overlapping colors without disturbing or diluting the previous wash (A).

A. ACRYLIC OVERPAINTING

Wet-in-wet Painting with Acrylic

Using the wet-in-wet technique with acrylic is a very rewarding experience. Wet your paper and touch it with a brushful of paint. The edges of the brush-strokes will run with great speed, but if your paint isn't too thin the brush mark will retain its streaky characteristics (B).

"Glazing" with Acrylic

The surface of acrylic paint usually dries while the paper still feels damp beneath it. This means that you can paint new layers of thin washes on top of your first washes as soon as they dry but before the paper dries completely. This "glazing" technique creates effects somewhere between those created by overpainting on dry paint and those that result from the wet-in-wet technique. That is, while colors tend to blend, they remain more distinct than they would if they were applied wet-in-wet (C).

Using Acrylic as Opaque Paint

After or instead of using transparent acrylic washes, you can paint on opaque or even thick impasto touches (D). Acrylic paint remains flexible after it dries, so you don't have to worry about the thick layers chipping off as they might with opaque watercolor.

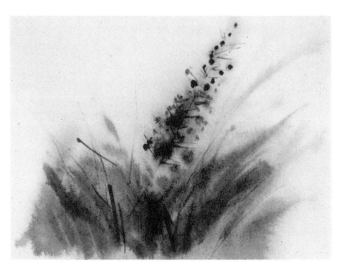

B. ACRYLIC WET-IN-WET

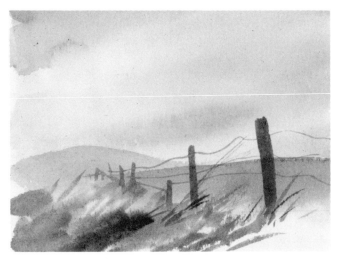

C. ACRYLIC "GLAZING"

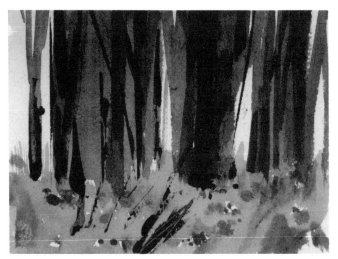

D. ACRYLIC WITH IMPASTO

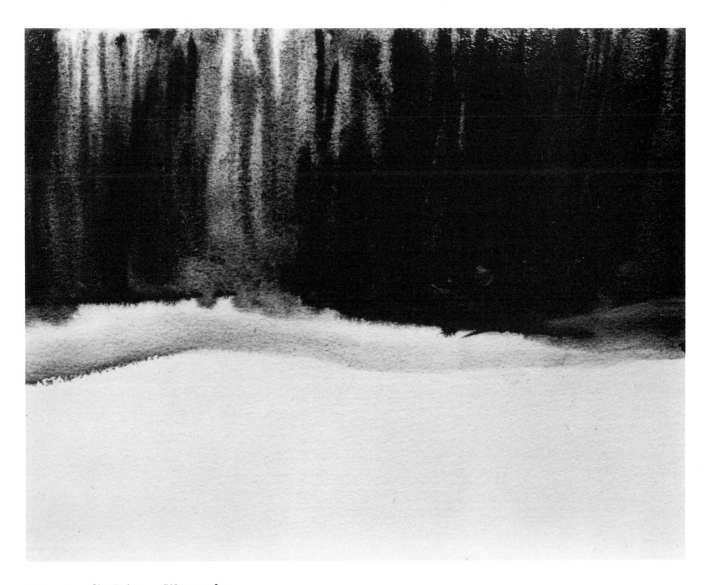

Using Acrylic Paint as Watercolor

Step 1. (300 lb. D'Arche's cold-pressed handmade paper.) I use a nylon acrylic brush to paint the dense colors of the forest's edge, mingling blues and browns on the wet surface.

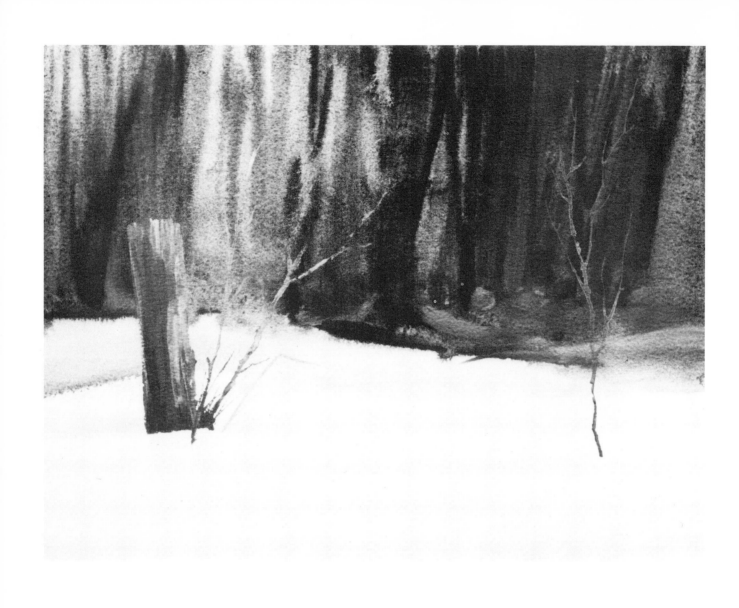

Step 2. As the paper dries, I paint the old fencepost—light at the top and dark at the bottom, with soft shadows hinting at deep snow. On the dry surface, I dry-brush some final details into the fencepost.

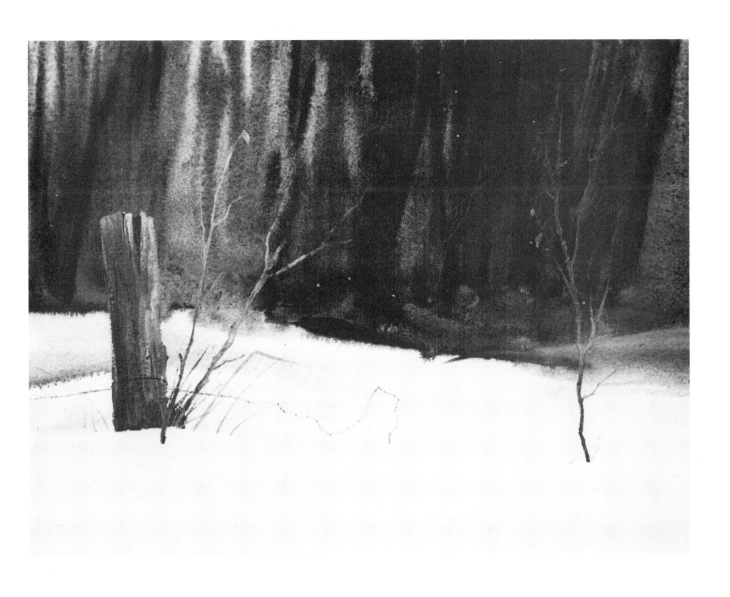

Step 3. Using a painting knife, I add scrawny twigs and some odd leaves to the young trees. The last touch is the barbed wire protruding from the snow.

7. Using A Painting Knife For Watercolor

The possibilities provided by applying watercolor with a painting knife haven't yet been truly exploited. When used with watercolor, the behavior of a fine steel blade is so unique that I consider it a must to at least introduce you to it in this chapter.

Materials

1. Your favorite transparent or opaque watercolor paints. My choice for the experiments to follow is the transparent medium.

2. One small and another, longer painting knife (A). Make sure the handles of the knives you use have crooks in them; these will prevent your fingers from accidentally touching the paper while you paint. Also be sure your knives don't have very sharp points, which would constantly catch on the texture of the paper, causing the knife to flick paint everywhere and generally creating a nuisance. A fine round point is ideal.

3. A piece of high-quality rag paper with a tough finish.

4. A sponge and/or a large, flat brush for wetting your paper.

5. A palette with lots of flat surface area for mixing.

6. A firm, medium-size brush to pre-mix your washes with.

7. Plenty of clean water and tissues.

If you've just bought a new knife or if you want to use an old one that you've used before with oil or acrylic, you must treat it so that it will accept water. If you have a thin layer of varnish on a new blade or old dried paint on an old one, you must scrape it off. The greasy quality of steel repels water so your paint will bead and roll off. To make the blade accept water evenly you have to remove the surface grease. One or two applications of household cleansing powder usually do a very efficient job. However, if the paint still doesn't stay evenly on your knife, stab the knife into a lemon and leave it in the fruit over night. The acid will take off the last trace of grease and your knife will be ready to paint with.

Begin as with a Brush

The most unnatural effect created by a painting knife is a soft wash. The sharp metallic edges of your knife can damage the surface of your paper. You have to avoid scraping the wet painting surface with the knife edges. Begin just as if you were painting with brushes, using a firm watercolor brush to mix a convenient size pool of the necessary color on your palette. The paint, even the dark colors, must be of liquid consistency for ideal results. Wet your paper using your sponge or wide brush. Dip your knife into the just mixed paint, submerging the blade completely.

The Gentle Touch

Hold the loaded knife horizontally while you move it over your paper to prevent surplus paint from dropping where you don't want it to. To apply the paint, touch the wet surface of the paper gently with the flat back side of the knife's tip and at the same time drag the knife with an even, gentle contact in the direction of the handle (B). Move quickly but with light pressure. The exciting results of this stroke will make the first few frustrating exercises worthwhile.

Creating Texture

Building texture in a wet wash is where the knife really can show off your skill. Press your knife's edge down firmly where you already applied paint in one direction and move it in the opposite direction with a motion like spreading butter. When one edge touches the paper, move toward the right, and vice versa (C). The pressure of your hand will squeeze most of the paint off the surface until you lift your knife. The extra paint you've moved ahead of your knife will run into the untouched wet area and slightly darken it. It won't go back where your knife squeeze-dried the surface. You can do this back and forth to achieve beautiful patterns that are impossible to imitate any other way, as, for example, the texture of distant rocks.

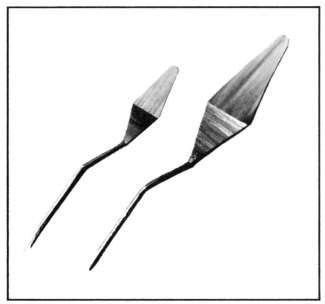

A. PAINTING KNIVES

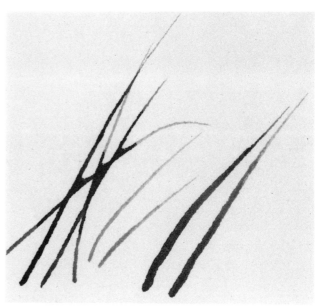

B. DRAGSTROKES

C. SCRAPING FOR TEXTURE

41

D. TREE TRUNK

E. BRANCHES

F. TWIGS AND WEEDS

Painting Tree

The most natural way to paint tree trunks and branches is to use your painting knife on dry paper. Let's start with the dark lower trunk. Use broad strokes of dark but liquidy pigment. Squeeze the barklike texture into the still wet paint as before (D). Continue until the branches become too fine for the side of the knife.

Putting in the Branches

For the heavier branches, hold a lightly loaded knife in an upright position allowing the paint to accumulate at the tip. Your fingers should hold the handle at the fattest point. Drag the knife with light pressure and a jerky motion, imitating the characteristics of branches (E). Don't lift the knife until it runs out of paint. As the knife loses its load, the line will become thinner and thinner and gradually stop. At the points where you have changed directions, you start new branches.

Adding Twigs and Weeds

To do the distant fine twigs that you see in the winter, hold the knife as if you were to cut the paper with the tip. Connect these fine lines to the heavier ones (F). This technical stroke is equally useful to paint soft, tall weeds or any fine line. It can provide you with an extremely thin though unremovable line if you apply your knife dry to a wet painted surface—for example, painting a telephone line on a wet sky (G).

Painting the Foliage

To get a drybrush effect for lacy details, use a coarse, rough, cold-pressed paper. Hold the loaded knife in a manner similar to the one you used for a soft wash (H). This time, however, you paint on dry paper. To force the paint to behave exactly the way you want it to, wiggle the knife left and right as you drag the paint. This stroke is extremely useful in painting foliage on trees, for example, or in building a weathered texture.

My final advice is just a reminder: learn to apply the correct amount of pressure to mix your paint to the correct consistency. The rest is a matter of practice.

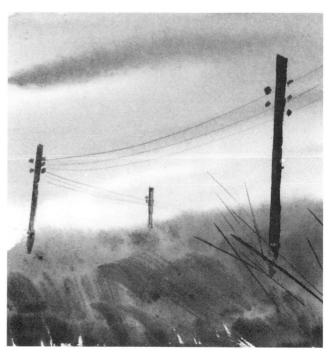

G. TELEPHONE LINE

H. DRYBRUSH EFFECT

Using a Painting Knife for Watercolor

Step 1. (300 lb. D'Arche's cold-pressed handmade paper.) On a haphazardly wet paper, I wash in a light sky, using the flat, rear, side of a painting knife and letting the paint blend freely. I wash in the foreground grass the same way, dragging the strokes into the dry areas. The yellow washes in the left background establish the color for the tamarack trees.

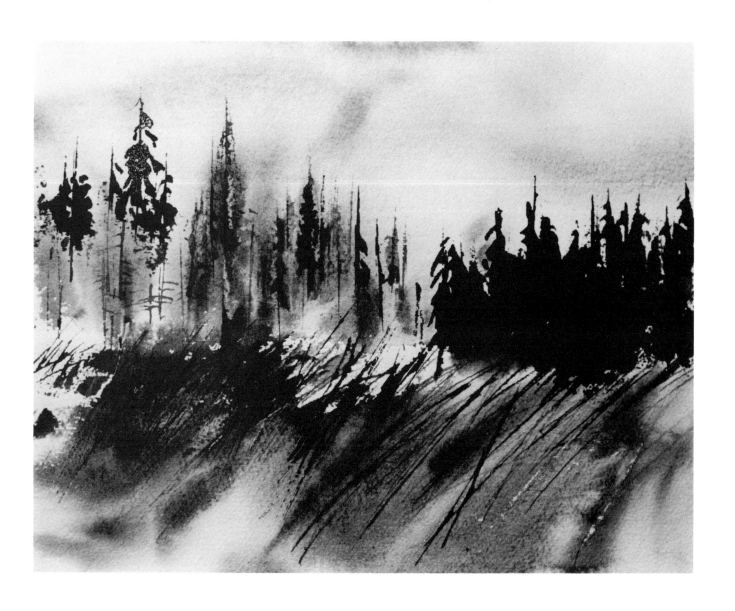

Step 2. Using a richly loaded painting knife, I paint the evergreens in the middleground with sharp, vertical contact strokes. The dense pine cluster on the right was produced by dragging the knife horizontally across the paper. Simultaneously, I add the treetops and thin, sharp grass for definition and balance.

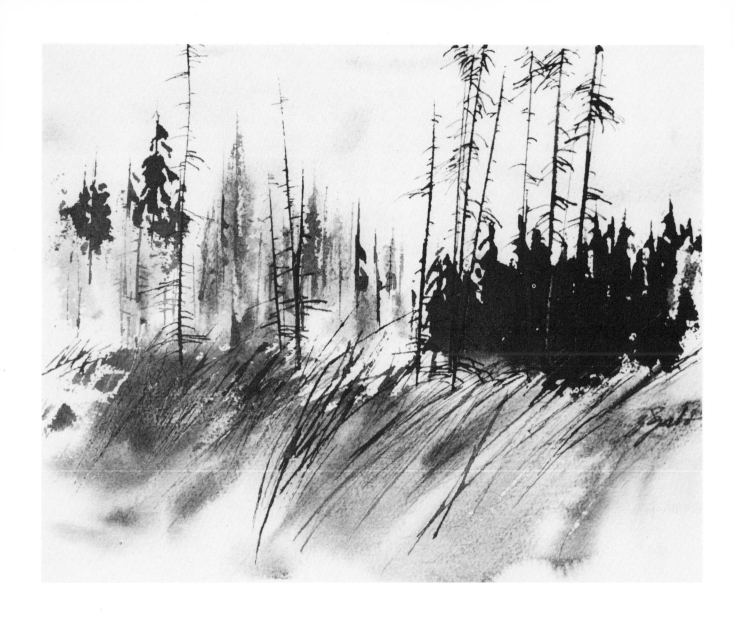

Step 3. Finally, I paint the tall, scrawny, dry trees in the foreground by holding the loaded painting knife upright and dragging its tip over the paper. I move the knife rapidly for the trunks and slowly for the dry twigs.

8. Using Salt and Sand

Salt and sand can be useful when you are after unusual textures. I use these because of their relative compatibility with regular pigments. Both are natural materials, and time has proven their stability and permanency.

Materials

1. Your usual transparent watercolors, brushes, and favorite handmade watercolor papers.

2. About a tablespoon each of table salt and coarse preserving salt.

3. Clean sand.

Dropping in "Stars"

As you know, salt dissolves in water. It also has the ability to absorb water and a lot of pigment with the water. To demonstrate this quality, paint a brushstoke of any color on your paper with a medium wet brush. Keep your paper in a horizontal position. Just before the wash loses its shine, drop one or two salt crystals into it and watch a little "star" form around each grain as the salt soaks up the paint solution (A). The size of each little star will depend on how wet your wash is at the time of application. The wetter the wash, the larger and fainter the star will be, because the salt granule not only absorbs water but dissolves itself. These forms have a delightful resemblance to snowflakes.

Creating Flowers

If you use one dye color and one earth color, you can create the effect of small flowers. For example, sap green and sepia alizarin crimson and sepia, or Prussian blue and warm sepia offer a variety of gardens (B).

Tilting the Paper

If you introduce lots of salt at one spot into a flowing wet wash and tilt the paper gently, you will end up with a flow of discolored salt solution that creates an edge something like that of jungle vegetation (C). The more you tilt the paper the further your salt will spread, giving you endless opportunities for abstract patterns. When using salt, *do not* use a fan or hairdryer to speed up the drying process. Their blowing force will roll the salt uncontrollably on the wet surface, giving an impression of sloppiness. I found that natural drying time gives me the best results.

Painting with Sand

For another unusual texture, use sand. I found the common, coarse building sand the most useful. Sand should be sprinkled onto your wet wash while your paper is in a horizontal position. Allow the paint to dry naturally. After it is dry, brush off the sand granules and you'll have a grainy texture. Your timing in applying and drying the sand, as well as the size, quantity, and nature of the sand particles, will give you a slight variation. Extremely fine sand doesn't offer a striking enough result to justify the effort in using it.

Experimenting for Different Results

I have prepared a few swatches of examples (D). As you can see, different colors and their consistency offer different results. I find the more transparent colors and light washes leave more clearly defined patterns. Experiment with salt and sand until you make sure you are using them in combinations compatible enough to protect the permanency of your pigments.

For the demonstration of *Using Salt and Sand* see the color plates on pages 84–85.

A. SALT STARS

B. FLOWER GARDEN

C. JUNGLE VEGETATION

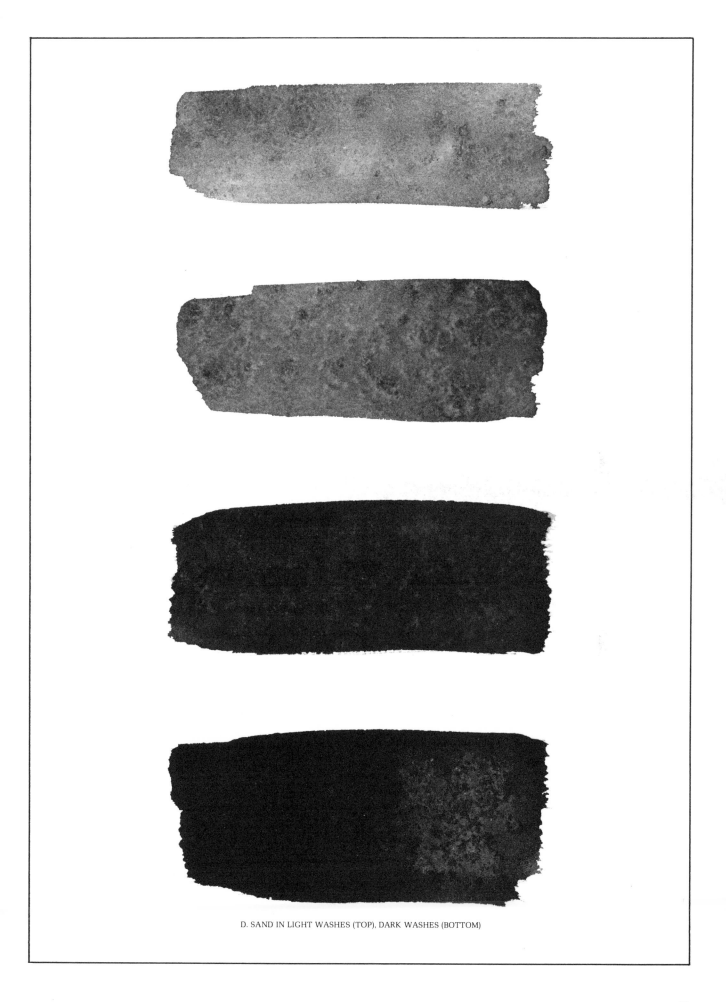

D. SAND IN LIGHT WASHES (TOP), DARK WASHES (BOTTOM)

49

9. Deliberate Backruns

Controlling backruns—the most abstract of watercolor accidents—is like taming a tornado. What is a backrun? I fabricated this term to define the result of one fresh brushful of watercolor running back into another wash that is in the process of drying. Though you can never control this action, you can certainly take advantage of its result.

Materials

1. Your transparent watercolors and brushes.

2. High-quality paper.

Timing the Backrun

What happens in a backrun is that after the fresh brushful of watercolor has run back into the drying wash, an uneven hard edge results. This edge occurs where the wet wash stopped because it ran out of the surplus water that had forced it to spread. To estimate the dryness of the first wash is the most difficult part of the game. Your best timing for the fresh paint is a little before the first wash dries enough to lose its shine.

Shaping the Runs

The shape of your backrun depends on the shape of your spreading brushstroke. For example, a drop of water or a drop of thin paint with a high water content will cause a circular backrun. Several of these droplets will create many circular runs blending softly where they touch each other but drying unevenly. The result is a circular edge that looks like fluffy cumulus clouds

Tilting the Paper

Water drops will radiate evenly in all directions if your paper is on a horizontal surface. If you tilt this surface, however, the water will move downward toward the lowest point of your paper (B)

Using Different Colors

If you use a color for the wet stroke different from the one you used for the drying pigment, you'll get some interesting effects. If on the edge of a blue-gray wash, like a forest in winter, you add an elongated stroke of burnt sienna, it will dry back to look like distant shrubs (C). This color play is particularly effective if your cool bluish hues are applied against warm browns or reds.

Pushing Back Non-Dye Paint

Should your first wash be a mixture of a dye pigment—such as sap green—and a non-dye color, your second wash will push back the latter for the simple reason that non-dye granular paint just sits on top of the surface. The dye color will stay, however, because it has stained the paper.

Experimenting with Papers

Backruns behave differently on different papers. They will diffuse farther on smooth paper than on rough. The slower the paper absorbs water the farther will your backrun spread, and vice versa. Illustration (D) shows similar experiments on hot-pressed, cold-pressed, and rough handmade D'Arches paper. No two papers react the same way, so you'll have to experiment with many backruns before you can begin to tame these tornadoes.

For the demonstation of *Deliberate Backruns* see the color plates on page 86–87.

A. BACKRUN

B. BACKRUN ON TILTED PAPER

C. DIFFERENT-COLORED BACKRUNS

HOT-PRESSED COLD-PRESSED ROUGH HANDMADE

D. BACKRUNS ON DIFFERENT PAPER TEXTURES

10. Impressing Real Objects into Watercolor

Of all the special ways of creating a watercolor painting, pressing real objects into wet paint can be truly exciting—providing discipline to use them wisely. The more sophisticated your choice of objects and colors are, the more unusual the result will be.

Materials

1. Your usual brushes, watercolors, and paper.

2. A can of acrylic spray.

3. A number of objects with a relatively flat side, convenient for printing. I have used tissue paper, leaves, and juniper twigs, but almost any object will do.

4. A cake of soap.

5. Some powdered starch.

You *do not* need a press. The pressure of your hand is all that's required.

Choosing the Right Paper

You must select the right kind of paper for maximum results. Smooth or hot-pressed paper gives the cleanest print, but medium-rough or cold-pressed paper offers a better chance to paint on top of the printed image simply because the paint doesn't loosen as easily as it does on smooth paper. Experiment on small swatches of different paper before making a final choice for a painting. Take notes on these swatches to help you remember later how you achieved particular effects. My illustrated samples are done on D'Arches cold-pressed paper and on 100% rag hot-pressed commercial paper.

Using a Maple Leaf

To illustrate the impressing technique, I will choose a few objects with interesting shapes—a maple leaf, a tissue, the cut end of a bamboo handle—and then paint a wash on a flat surface and immediately press the object into the wet paint. The paint-covered article is placed carefully on the clean dry paper. After gently laying a tissue on the surface of the paper where I wish to avoid undesirable smears, I press on the painted object until the paint is transferred from it to the paper. The surfaces of some objects—feathers, the fuzzy side of a maple leaf—repel water, so before I dip these into my wash I paint them with a quick coat of soap. They then work nicely. This procedure is illustrated with a few examples (A). I mix a quantity of powdered starch into my wash and repeat the printing procedure with another maple leaf; the swatch and the print after drying is shown in sketch B. In illustration C, I paint directly onto the leaf and print it as described above.

Impressing Tissues

Illustrations D and E show some uses for ordinary household tissue. The impressions are made with a tightly bunched up tissue squeezed between my thumb and two fingers dipped into a wet surface. Because of its extremely absorbent quality the tissue removes a good deal of paint from a wash, leaving an interestingly textured shape. It transfers very little paint, however, in spite of heavy pressure. You can improve the printing quality of an absorbent surface by covering it with an acrylic spray. Wait a few minutes until the spray dries and then proceed as before. You'll see a noticeable improvement, as my example E with tissue indicates.

Applying a Bamboo Handle

The cut end of a bamboo or soft, wood brush handle has enough absorbent quality to remove the paint from a wash when you press it into a rich, damp surface. In illustration F, I have painted a quick wash on smooth paper. The flower petals are done with the end of my bamboo brush handle, the leaf with the edge of the wood handle. To get a relatively uniform tone, the brush handles are cleaned of surplus paint between each rapid contact with a tissue in my left hand.

Further experiments with impressing real objects will offer you an endless number of ideas. Discipline and good taste should guarantee your success.

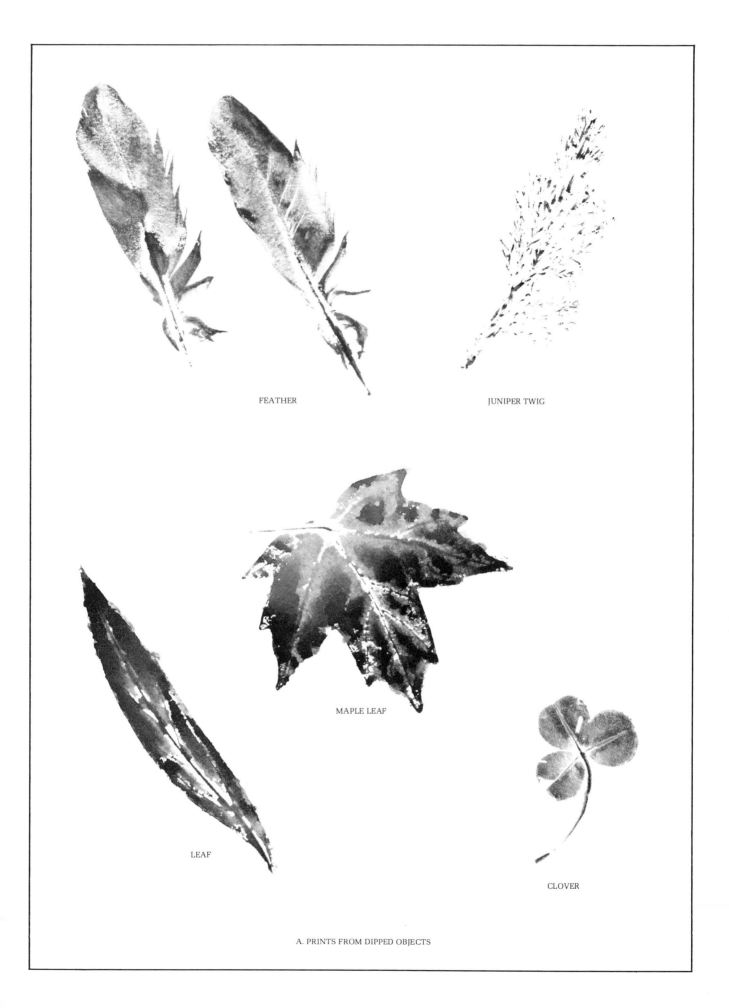

FEATHER

JUNIPER TWIG

MAPLE LEAF

LEAF

CLOVER

A. PRINTS FROM DIPPED OBJECTS

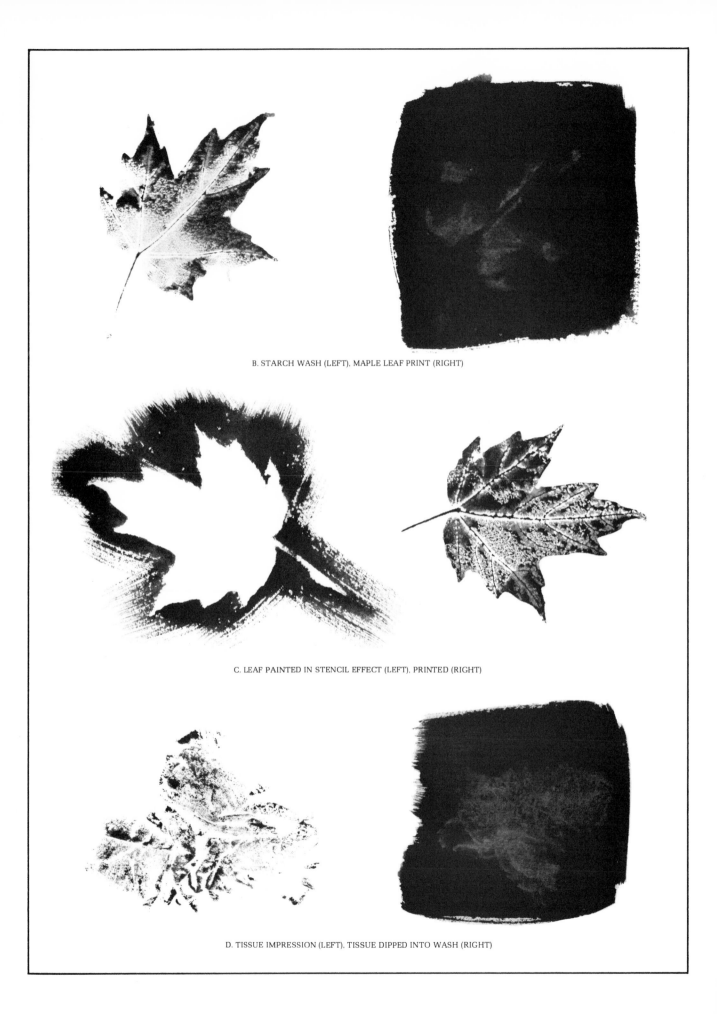

B. STARCH WASH (LEFT), MAPLE LEAF PRINT (RIGHT)

C. LEAF PAINTED IN STENCIL EFFECT (LEFT), PRINTED (RIGHT)

D. TISSUE IMPRESSION (LEFT), TISSUE DIPPED INTO WASH (RIGHT)

SPRAYED TISSUE

UNSPRAYED TISSUE

E. TISSUE IMPRESSIONS (LEFT), DIPPED INTO WASH (RIGHT)

F. BAMBOO HANDLE IMPRESSION

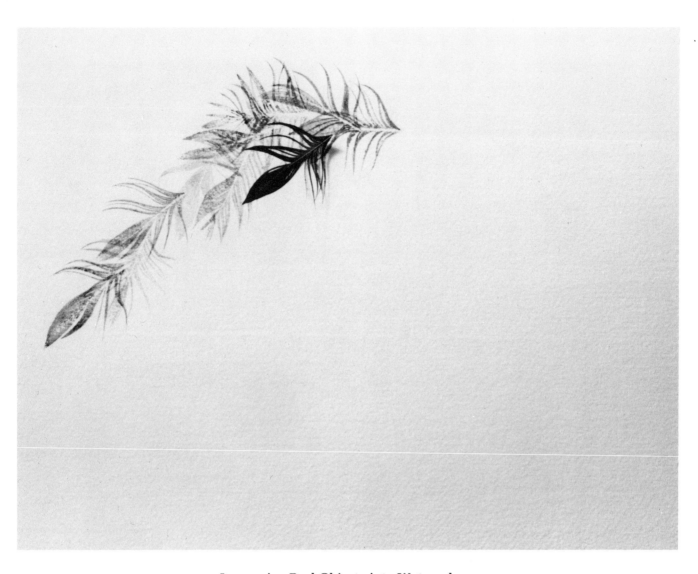

Impressing Real Objects into Watercolor

Step 1. (300 lb. D'Arche's cold-pressed handmade paper.) After brushing soap on both sides of a little feather, I paint a rich coat of blue-gray color on it. I place it carefully on dry paper and with a double-folded tissue press it to the surface. This process is repeated over and over again. This illustration shows the actual wet feather in place before impression.

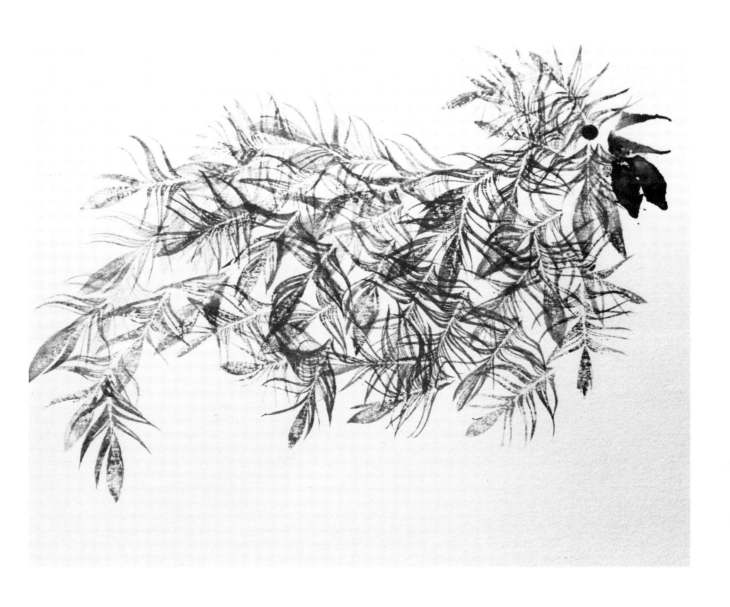

Step 2. By repeating Step 1 many times, I create the form of a chicken. A dab of paint on the rubber tip of a pencil makes the eye. A leaf folded in half for the beak and opened flat for the wattles below, help me to define the head.

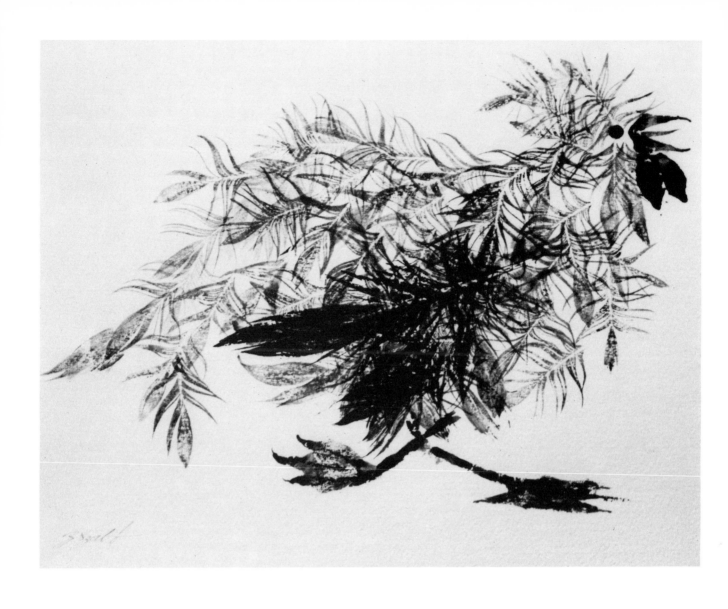

Step 3. Leaves dipped into bright red help me indicate the chicken's running feet and its tongue. I press on a large wing feather with black paint to add dimension and humor.

11. Turpentine and Spray Fixatives with Watercolor

When wet, spray fixatives and turpentine resist water. Both are made to protect pigments, so you can be sure of their compatibility with watercolor paint. Many other water-resistant chemicals are available, so by all means experiment with them. Learn all about them, however, before you use them on paintings.

Materials

1. Your regular transparent watercolors, brushes, and handmade watercolor paper.

2. A small bottle of turpentine.

3. One can of damar varnish spray.

4. One can of letraset matt fixative.

5. One can of glossy pastel fixative.

6. One extra brush to be used in turpentine only—the bigger the better.

Painting over Turpentine

Of these materials, turpentine gives the most definite and predictable result. But because it evaporates rapidly you must have your watercolor mixed, ready to paint before the turpentine dries. You may apply turpentine on pure paper as well as on top of dried washes (A). You may use it two or three times in the same area as long as you allow each wash to dry completely before applying the next one. Once the turpentine is absolutely dry, you can proceed to brush on a wash in the usual way. In your search for a variety of textures, you'll find that the exciting beading effect that turpentine creates under a wash has a million uses, such as for rock, bark, and concrete surfaces.

Mixing a Solution

Another more limited, but very exciting use of turpentine is in a mixture of diluted watercolor (B). The watercolor will collect in large beads in the mixture. If you shake the solution vigorously, you'll reduce the beads to tiny blobs, but they will stay separate. With a soft brush, paint on this mixture of different size beads, and you'll see that watercolor remains intact on top of the turpentine-soaked paper. As the turpentine dries the paint will stick to the paper surface and dry in the same place it was in when wet.

Using Varnish

You can get a similar result if you use damar varnish in much the same way as turpentine (C). Spray varnish and bottled varnish are both good. However, please remember that the varnish will penetrate the paper and *will stay* there; it will not evaporate. Use it sparingly.

Applying Acrylic Sprays

Acrylic sprays behave similarly, and if your timing is right offer a rich, wet-looking texture (D). I have used Kem Higloss acrylic spray enamel under a wet wash as well as letraset matt fixative (E). The results shown are self-explanatory, though it must be noted that the letraset spray on top of a wet wash gives a very superficial effect and is easily damaged. (F).

A Word of Caution

I would like to repeat a word of advice: avoid excessive use of these chemicals. If you don't your paintings will become gimmicky. Use them when you need them, but *only* when you need them.

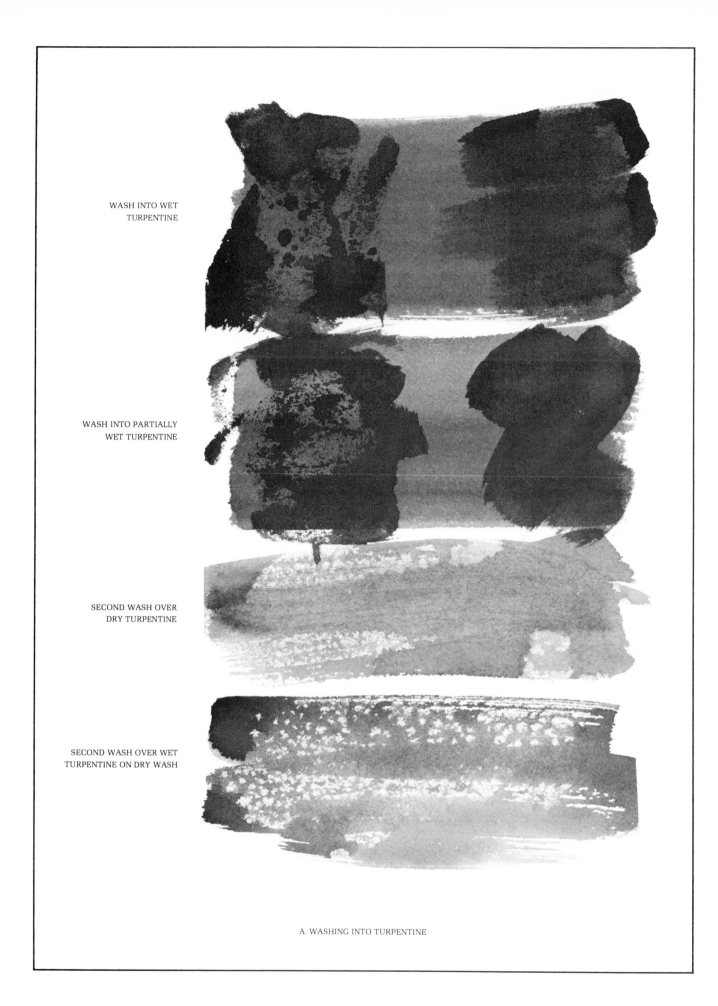

WASH INTO WET
TURPENTINE

WASH INTO PARTIALLY
WET TURPENTINE

SECOND WASH OVER
DRY TURPENTINE

SECOND WASH OVER WET
TURPENTINE ON DRY WASH

A. WASHING INTO TURPENTINE

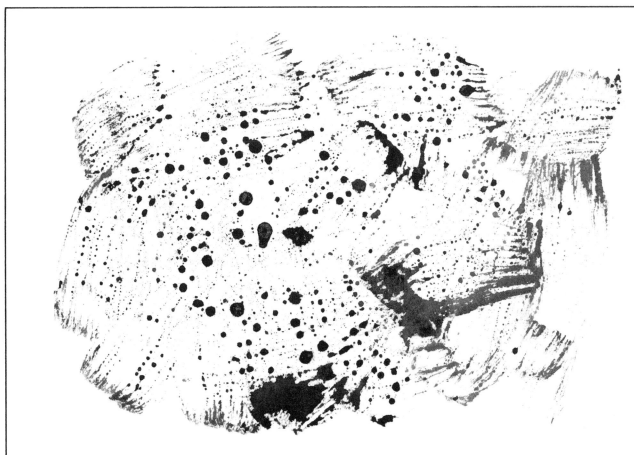

B. WATERCOLOR AND TURPENTINE

C. DAMAR VARNISH

D. SPRAY ENAMEL

E. LETRASET MATTE

F. DAMAGED LETRASET

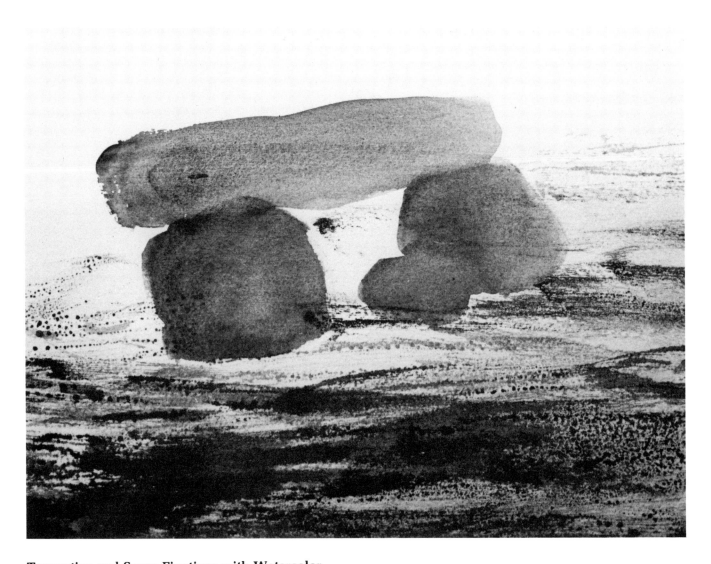

Turpentine and Spray Fixatives with Watercolor

Step 1. (300 lb. D'Arche's cold-pressed handmade paper.) I soak my paper with turpentine washes until it is shiny wet. Using a soft, flat 1″ brush, I slap the wet brush across the foreground to show the gravel beach. (Since the turpentine dries rapidly, I have to wash to keep up with it.) Onto the dry paper, I paint the base tone for the funny rock formation.

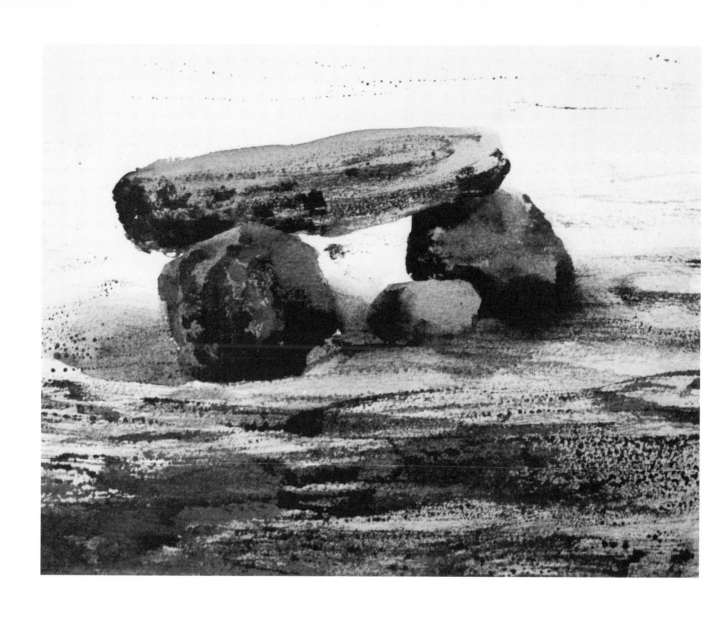

Step 2. Using a similar sable brush, I better define the boulders and add another, smaller rock. Again with the soft, flat brush, I put the blue-gray shaded dip to the left of the rocks and add a few drybrush hints of the lazy waves to come.

64

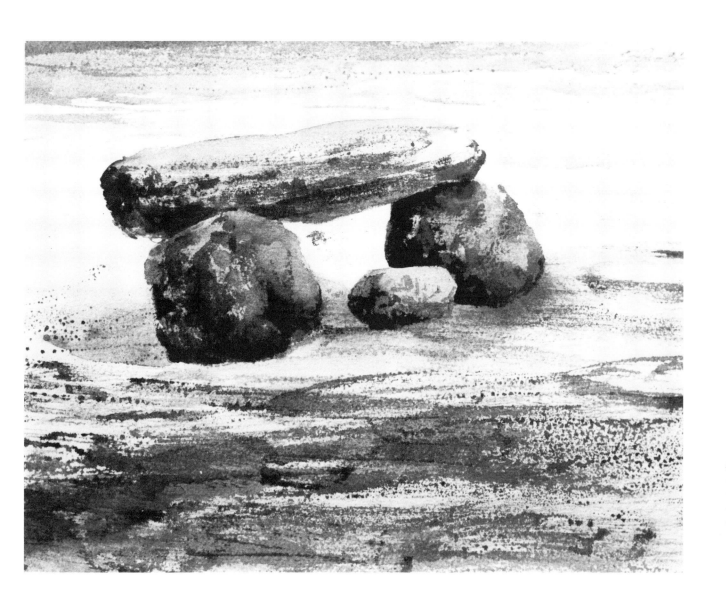

Step 3. With quick horizontal strokes, making two or three passes with light blue washes over the turpentine-dampened paper, I paint the waves at the top.

12. Starch and Watercolor

The effects that starch provides in its use with watercolor are positive. The technique, however, is more troublesome to the artist than the viewer can judge from looking at the finished product. Again, you're urged to use restraint.

Materials

1. Your usual palette of watercolors, brushes and paper.

2. One small bag of laundry starch in powder form.

3. One can of spray starch.

4. A small pan or plate for mixing.

The more starch you mix with your color the lighter and more opaque it will become. Always mix your washes in a separate pan by adding clean paint to the starch and not the other way around.

Varying the Consistency

In my illustration A you can see a regular wash, a wash with starch powder mixed into it for a creamlike consistency, and a wash with lots of starch to form a paste with the consistency of thick sour cream.

Changing the Value

In my next illustration on smooth paper you can detect the value change (B). In the top right corner I show you the value of warm sepia and green before I add starch to it. The sketch is much lighter. The starchy wash is responsive to modeling because the brush or dab marks survive much as they do with oil paint.

Using a Loaded Brush

When I paint into a wet clear starch wash using a well loaded bristle brush, the paint does not spread out as fast and as far as it does on wet paper that has no starch on it. (C). The irregular edges and the crackled texture are unpredictable bonuses.

Applying Starch Paste

Starch paste mixed with watercolor should be used on a solid surface, such as illustration board or Masonite, to which a white or green latex undercoating has been applied to prevent cracking if the surface is bent (D). This paste can give you a drybrush effect even on smooth paper. It'll show every hair mark of your brush as you apply it (E).

A. STARCH PASTE (LEFT), STARCH WASH (CENTER), REGULAR WASH (RIGHT)

B. STARCH WASH DABBED AND BRUSHED

C. PURE PIGMENT INTO STARCH WASH

D. STARCH PASTE APPLIED WITH KNIFE

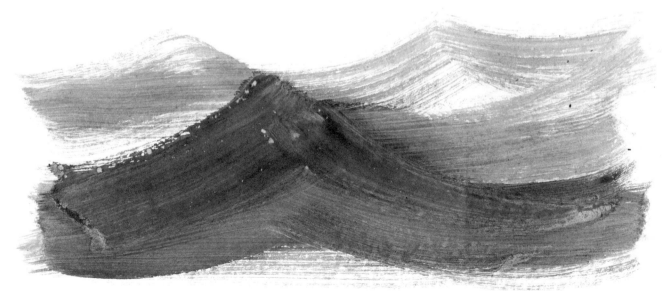

E. STARCH PASTE APPLIED WITH BRUSH

F. WASH INTO SPRAY STARCH (TOP),
SPRAY STARCH OVER DAMP WASH (BOTTOM)

Working with Spray Starch

Spray starch behaves in the same manner as starch powder, except that with spray starch your consistency is already established. You can only use it in washes, it is to thin for paste. In my little illustration F I have sprayed the top of the paper (above the pencil line) with spray starch. I then immediately paint the heavy washes into this surface, dragging the strokes onto the dry surface of the paper (below the pencil line). As this wash starts to dry and loses its shine, I give a quick squirt of spray starch to the damp paint, thereby creating the white matted effect.

Starch is compatible with watercolor. Use it with safety, but use it only if you have a creative reason for doing so.

For the demonstration of *Starch and Watercolor* see the color plates on pages 88–89.

13. Sponge and Watercolor

Sponges are old friends of the watercolor painter. Their conventional use is to wet and scrub the paper in preparation for stretching or painting. In this chapter I will deal with some of the more productive uses of this versatile tool.

Materials

1. Your usual watercolor paint, brushes, and paper.

2. One egg-size natural sponge.

3. Several synthetic sponges varying in size from a cigar box to a wallet.

Getting the Feel of Sponges

You'll get the best response from your sponge if you moisten it before use. Its dampness is ideal for transferring paint or for blotting. Just to get the feel of your sponges, mix a heavy load of dark color on a flat dinner plate or the top of a washable plastic table or on a sheet of glass. You need a fairly ample flat surface for a palette. Dip each one of your sponges into this prepared wash and then make an imprint on clean dry paper by pressing the paint-covered sponge *gently*. The result will show you the exact natural pattern that a sponge can offer (A).

In the same manner make additional printings with a soft dabbing motion, using each type of sponge separately as before (B). After this pattern dries, go over it a second time with the paint-laden sponge (C). The second application will result in a stronger tone.

Emphasizing Differences

To build up strength and character in your impressions, apply three layers but use various sponges (D). First paint on a dark color, and then three different colors to emphasize the difference (E).

Choosing Possibilities

In the illustrations of glacial rocks in F and G, I show two practical applications chosen from an endless array of possibilities. In one I apply a simple, fast, damp wash and gently press a large, flat, thirsty, synthetic sponge onto it. In the other I let the basic wash dry and then dab on the texture, using first a fine and then a coarse synthetic sponge.

Painting for Effects

I have begun the two approaches to wooden fences in H and I by brushing on the board shapes quickly. In the darker one I drag a clean, thirsty sponge over damp, dark paint, and this results in a grainy texture. In the lighter illustration I paint the grain on top of the first light wash with a darker brown on my sponge and with just enough pressure to make a mark. The grass effect is achieved by using the same sponges as you would a drybrush.

I hope you'll remember not only when but when *not* to use a sponge. It must remain a creative tool, not a crutch.

For the demonstration of *Sponge and Watercolor* see the color plates on pages 90–91.

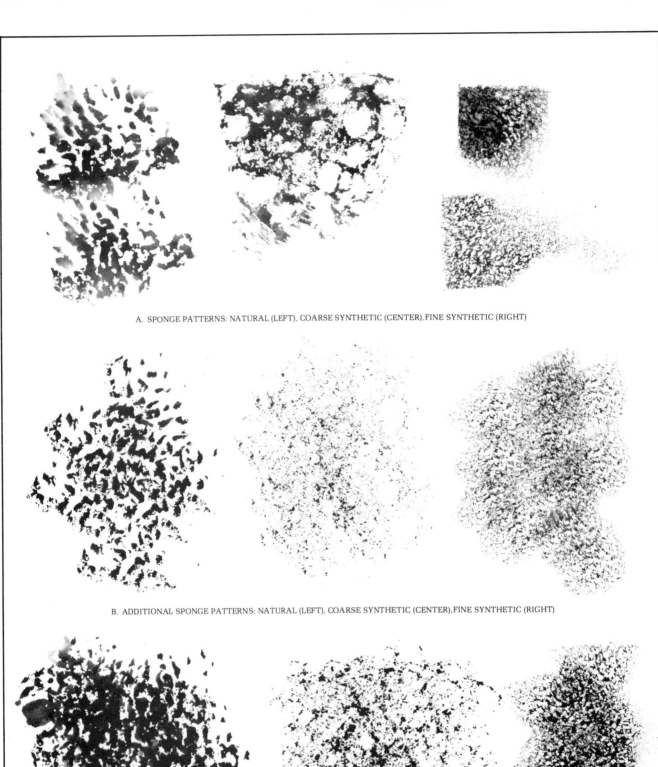

A. SPONGE PATTERNS: NATURAL (LEFT), COARSE SYNTHETIC (CENTER), FINE SYNTHETIC (RIGHT)

B. ADDITIONAL SPONGE PATTERNS: NATURAL (LEFT), COARSE SYNTHETIC (CENTER), FINE SYNTHETIC (RIGHT)

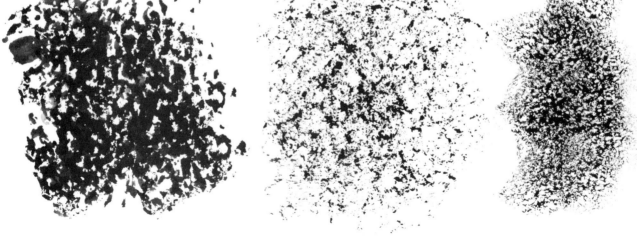

C. TWO APPLICATIONS: NATURAL (LEFT), COARSE SYNTHETIC (CENTER), FINE SYNTHETIC (RIGHT)

D. SYNTHETIC AND NATURAL SPONGE IMPRESSIONS

E. SYNTHETIC AND NATURAL SPONGES DIPPED INTO COLOR

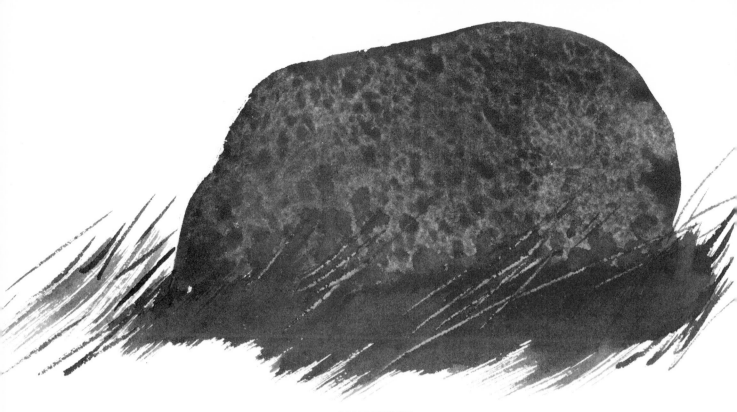

F. BLOTTED WASH

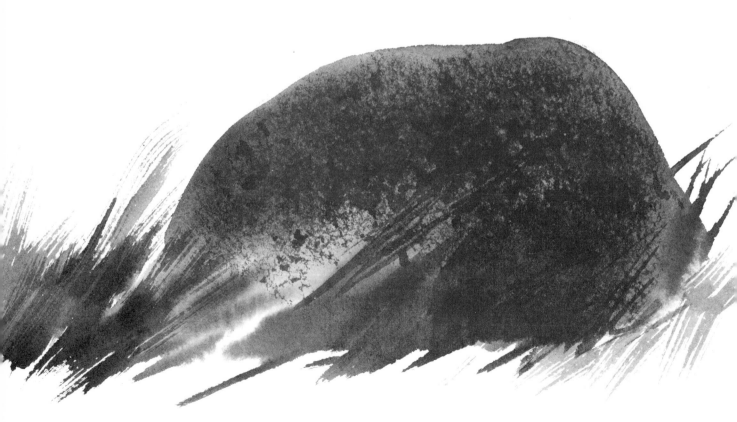

G. DABBED-ON WASH

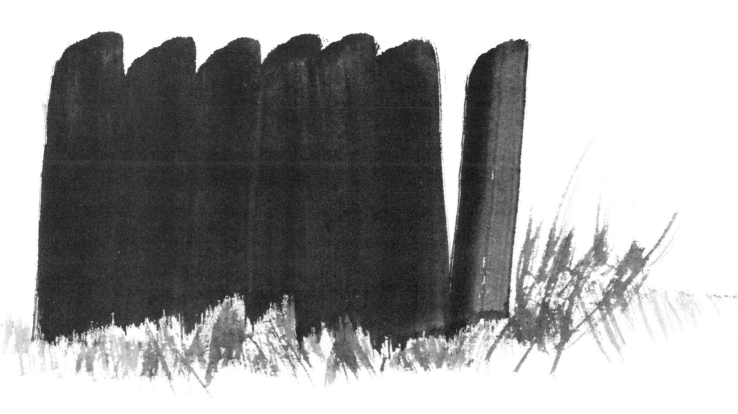

H. DRY SPONGE BLOTTING OFF DAMP WASH

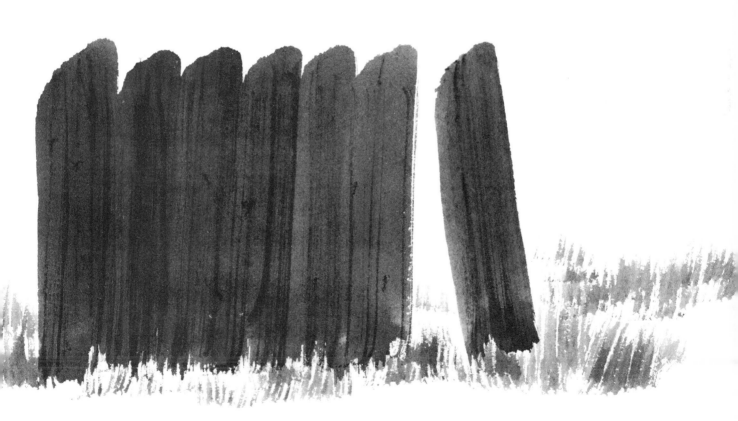

I. SPONGED-ON PAINT OVER DRY WASH

14. Watercolor and Japanese Papers

The Japanese paper industry has reached such a high standard in the production of quality papers that I would like to introduce you to the fun of experimenting with them. Many are made from rice, and any paper importer can advise you about their basic qualities. Only you, however, can tell which paper is suitable to your particular painting requirements, and you can best determine that by buying some samples and trying them.

Materials

1. Regular watercolor paints.

2. One wide and two or three smaller sable brushes.

3. One bristle brush about ¾″ wide.

4. Painting knife.

5. A variety of Japanese papers.

6. Some wet-strength tissue.

Practicing on Wet Tissue

Fortunately, most Japanese papers are inexpensive. But because they are so delicate, you may have difficulty experimenting with them freely. To break down your timidity and to give you a basic idea of what it is like to work with these beautiful papers, try first to paint on a wet tissue. The surface of wet tissue is also very frail, and a few brushstrokes on it will give you an *approximate* idea of what to expect when you paint on the soft Japanese papers. Of course, not all Japanese papers are soft. Some have a hard, smooth surface. They also offer a greater variety in color, from pure white to yellowish grays. The assortment of their texture is endless as well. I'll now introduce you to some of my favorite papers and show you have they behave under the brush.

Painting Wet-in-Wet

Iyo is a warm white, softly textured paper on one side and a little smoother on the other. I have used the wet-in-wet technique on the mottled side (A). The paper gives a dreamlike, soft diffusing effect to the paint that speaks for itself.

A. WET-IN-WET ON IYO (ROUGH)

Applying the Knife

On the smoother, dry reverse side, I have drawn some knife lines (B). After they dry, I again wet the surface with a soft brush and apply the touches of color. As you can notice the dark knife lines do not run from re-wetting the paper. This surprising quality suggests in-numerable possibilities for line and wash techniques.

With such encouragement, I now apply a straight palette knife to the rough side after the paper has dried (C). I drag, scrape, squeeze, and wiggle the knife, and I can tell you this paper can take it. The colors stay brilliant and clean, and they blend well and can be maneuvered beautifully.

Using Different Brushes

Musa is a blue-white, thin, hard-surfaced paper. It resembles the North American bond in texture and behavior on one side. The reverse side, however, is rough and coarser.

I use the rough side first. I apply the paint with a soft, wide, 1″ sable brush and the thin edge of my small painting knife (D). The same side of the paper behaves violently when wet. I paint with a heavy load of pigment on a bristle brush (E). The paint spreads out fast and far, going slightly out of control. The color dries paler than usual but the scrape marks from the brush handle survive well enough to give a touch of line

B. PAINTING KNIFE ON IYO (SMOOTH)

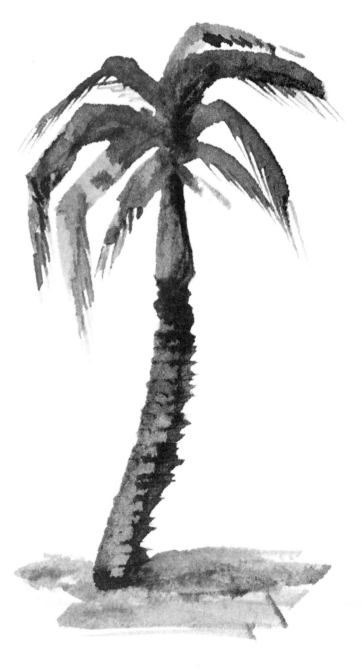

C. PAINTING KNIFE ON IYO (ROUGH)

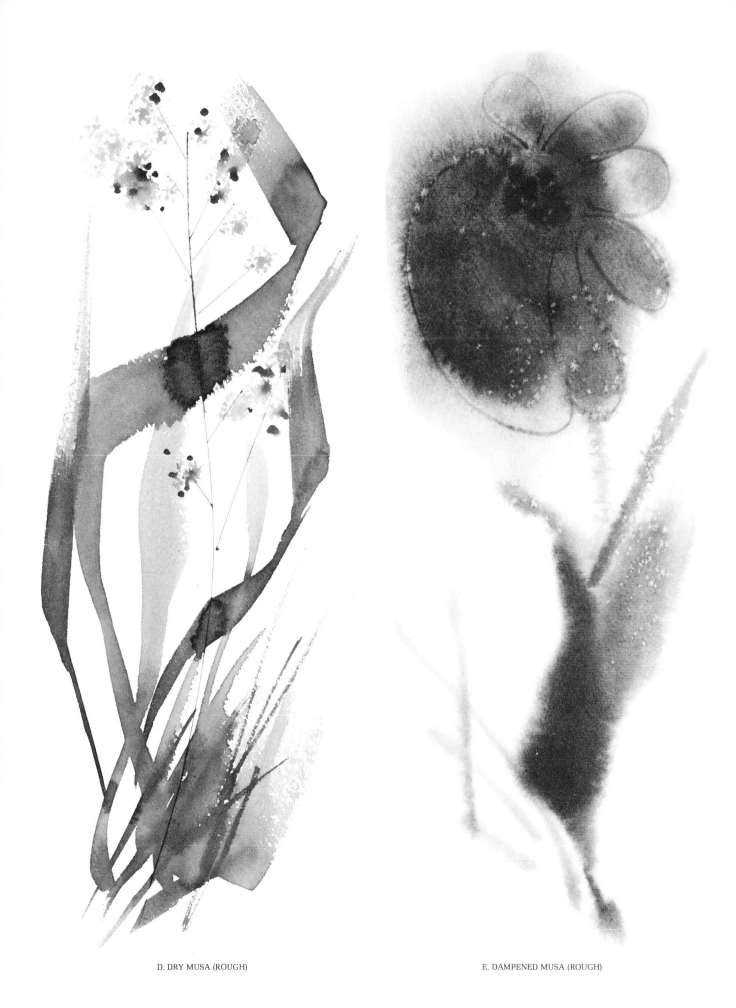

D. DRY MUSA (ROUGH)

E. DAMPENED MUSA (ROUGH)

complement. The little star shapes are a total surprise. Quite possibly, the manufacturer used salt in the paper to increase its permanency in tropical climates.

Neither the wet-in-wet nor the bamboo knife technique show any sign of the stars on the smooth side of the Musa paper (F).

Yok is a hard, smooth, blue-white, thin paper. It buckles badly, and is hard to control. The sample sketch G should tell you about its unusual qualities.

Painting Rapidly

Okawara is my favorite of the Japanese papers that I'm listing for you at this time (H). It is heavy enough to resist buckling, yet its creamy color and beautiful texture make it feel like cloth. It absorbs paint so fast that you can expect the second brushful to survive while the first is still damp. It is fun to use, possessing unique qualities for the speedy application of watercolor. Colors dry subtly, complementing the tone of the paper.

Kitakata is a smoother and much thinner brother of Okawara (I). It has the same creamy color, absorbs paint about as fast, and colors on it dry similarly. But because it is delicately thin paper, the edge of your painting knife can cut it under even the slightest pressure.

Using a Workhorse

Last but not least of my preferred Japanese papers is the old Sumi-e workhorse rice paper (J). It comes in a variety of thicknesses and shades. Resembling a blotting paper in behavior, Sumi-e has a lovely texture and is extremely absorbent. Colors survive rich and clean. Of all the Japanese papers that can be used with watercolor, this one is the easiest to purchase and usually the least expensive.

I hope that you'll find these lovely papers as stimulating to use as I do. Somehow they permit you to look into the oriental spirit—and to appreciate dreams even more.

For the demonstrations of *Watercolor and Japanese Papers* see the color plates on pages 92–93.

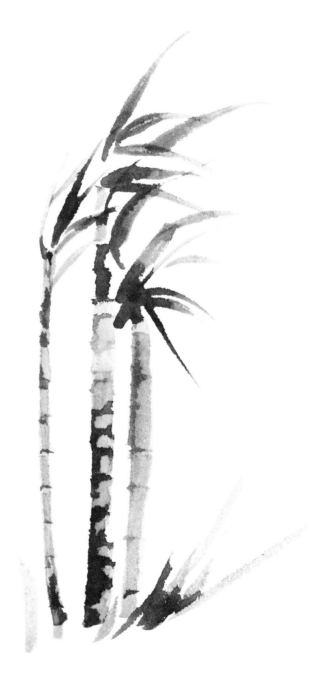

F. MUSA (SMOOTH)

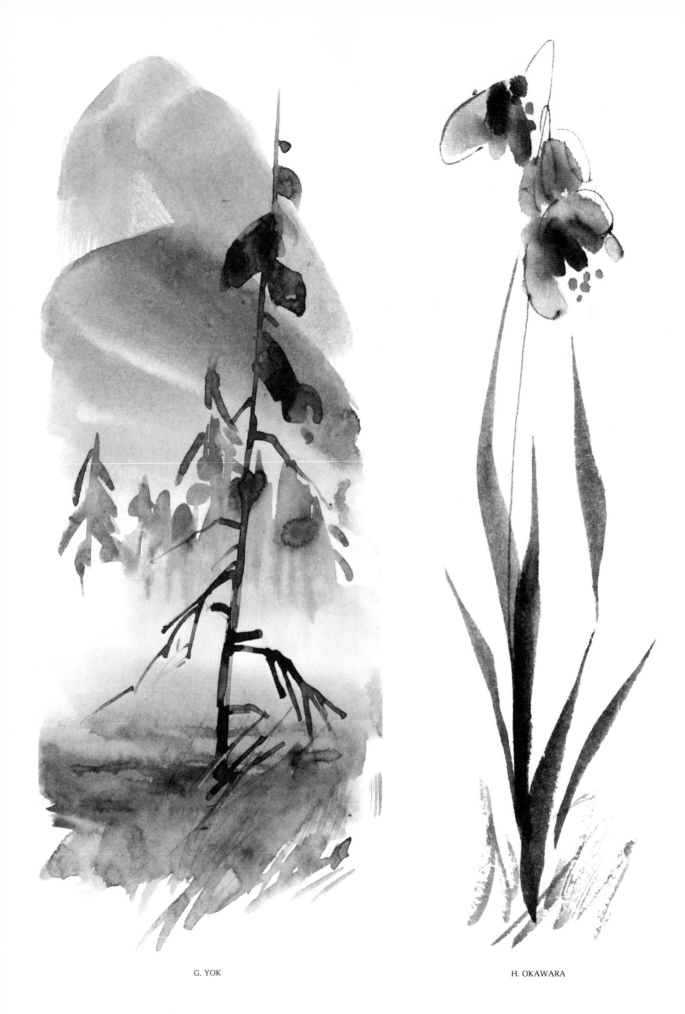

G. YOK

H. OKAWARA

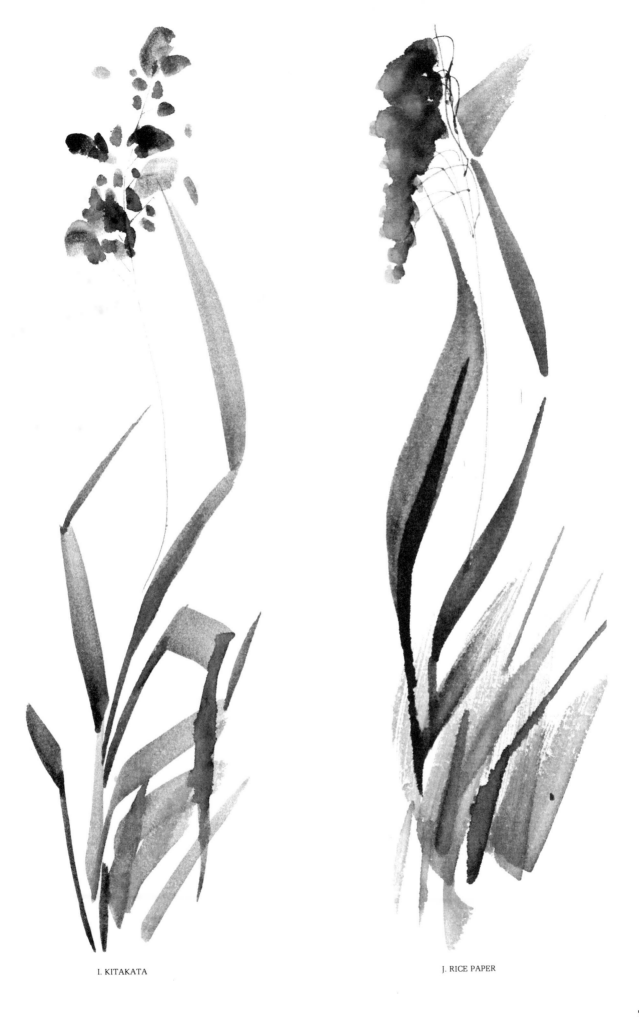

I. KITAKATA

J. RICE PAPER

79

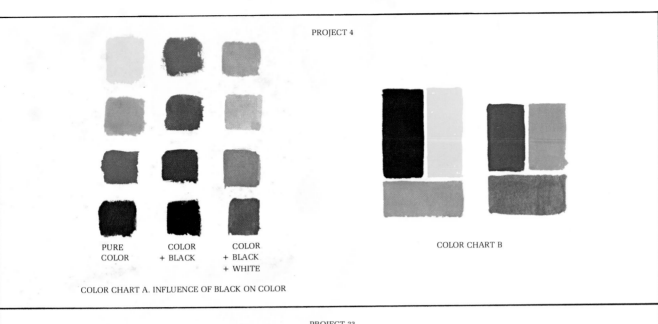

PURE
COLOR

COLOR
+ BLACK

COLOR
+ BLACK
+ WHITE

COLOR CHART B

COLOR CHART A. INFLUENCE OF BLACK ON COLOR

PROJECT 23

1

2

1+2+3

1 2 3

OVERPRINT CHART A. SPEEDBALL COLORED INKS

PRIMARY SECONDARY CONVENIENCE

VALUE CHART OF SPEEDBALL COLORED INKS

MORE COLOR CHARTS ON PAGE 112

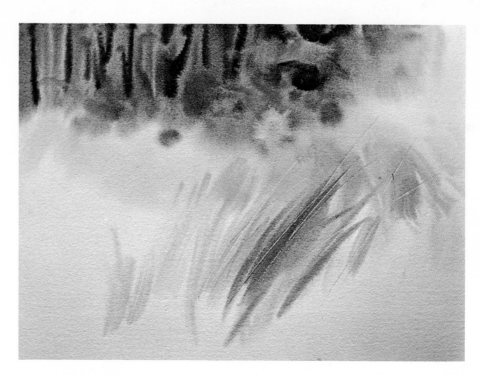

Step 1. (300 lb. D'Arche's cold-pressed handmade paper.) Starting on wet paper, with a bristle brush and transparent watercolor, I vigorously stroke in the dark, distant forest.

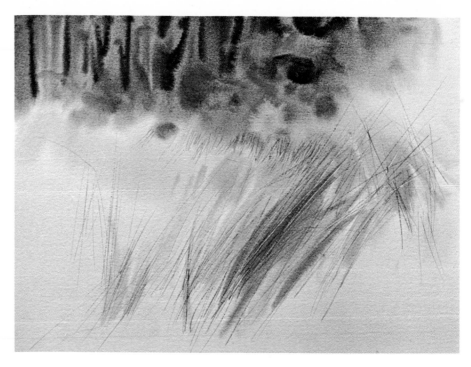

Step 2. I follow with applications of varied colors and transparencies, hinting at soft weedy values.

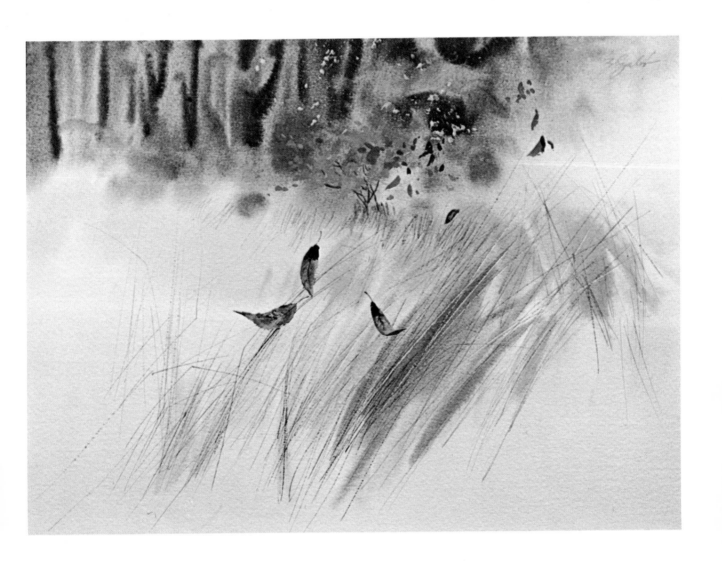

Step 3. When the paper is dry, I use thin touches of opaque watercolor to paint the small shrub in the middleground, its branches, and some of the fine weeds. Then I splash on sparkling yellow and red falling leaves with thick opaque watercolor, defining the closer leaves better. The larger leaves landing on the weeds offer a finishing touch.

**Using Salt and Sand
(Project 8)**

Step 1. (300 lb. D'Arche's cold-pressed handmade paper.) To paint the fresh outdoor atmosphere, I mark out with masking tape the space visible through the broken window. I wet this area of the paper and paint the misty, snowy landscape onto the wet surface. As the paint dries and before the shine disappears, I sprinkle on a few grains of salt which dry to look like snowflakes.

Step 2. After the snow scene dries, I remove the masking tape and brush off the salt. Then I mask the inside edges of the broken window, including a glass chip at the bottom. For the old glass pane, I stroke on a generous wash of various colors: cerulean blue, yellow ochre, sepia, and french ultramarine (ultramarine blue). Onto this, I sprinkle dry, coarse building sand. When this dries, I remove the masking tape.

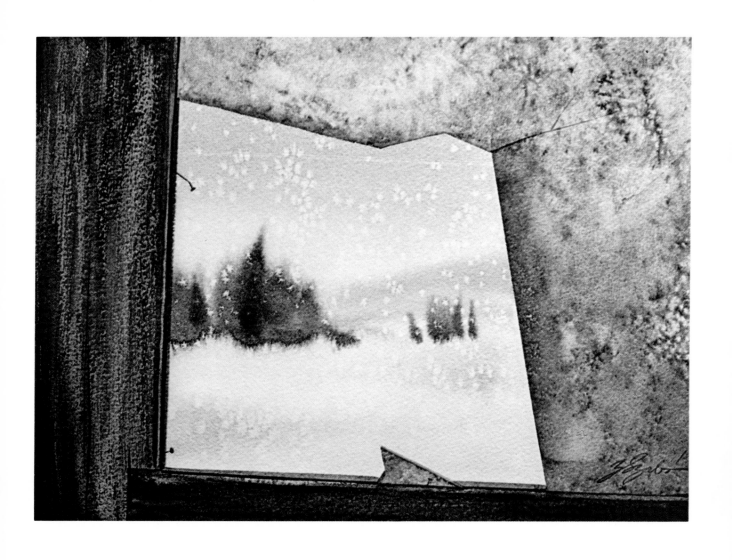

Step 3. Using a bristle brush, I paint the window sill a rich, warm brown wash to establish the value and color of the old wood. Adding the textural details of the wood grain finishes the job.

Step 1. (300 lb. D'Arche's cold-pressed handmade paper.) On a wet surface, I use a bristle brush loaded with rich browns and grays to paint the suggestion of a forest in the background and the tall weeds in the foreground. I add touches of alizarin crimson for the tall fireweed blossom. Just as the shine disappears from the paper, I drop touches of clear water onto the lower edge of the forest, causing backruns.

Step 2. When the surface is dry, I add definition to the flower and to the tall grass.

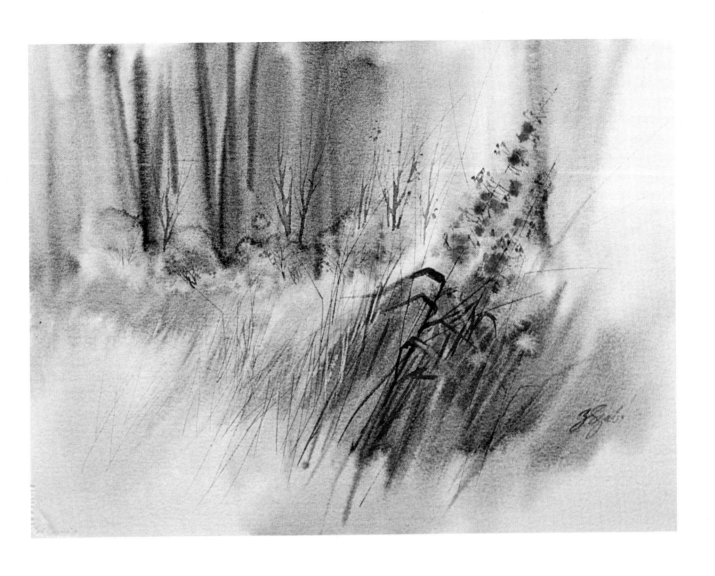

Step 3. With a few knifestrokes, I add the young trees above the backruns so that they now look like rich foliage on shrubs.

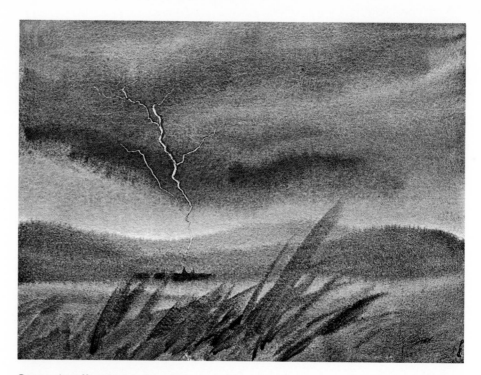

Step 1. (300 lb. D'Arche's cold-pressed handmade paper.) I spray the whole surface with spray starch and brush it even with a wide housepainter's brush. Using a soft, flat 1″ brush, I paint the somber, stormy sky, the distant hill, and the mass value of the foreground weeds. As the drying paint loses its shine, I scratch in the lightning with the tip of a pocketknife.

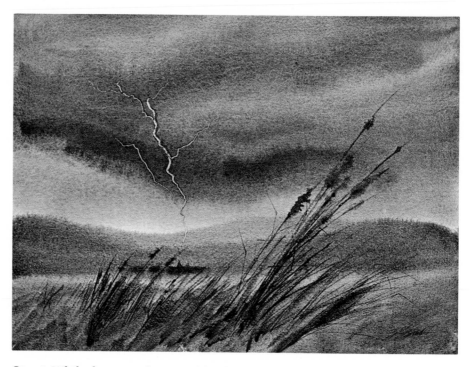

Step 2. While the paper dries, I add definition to the leaning grass and weeds.

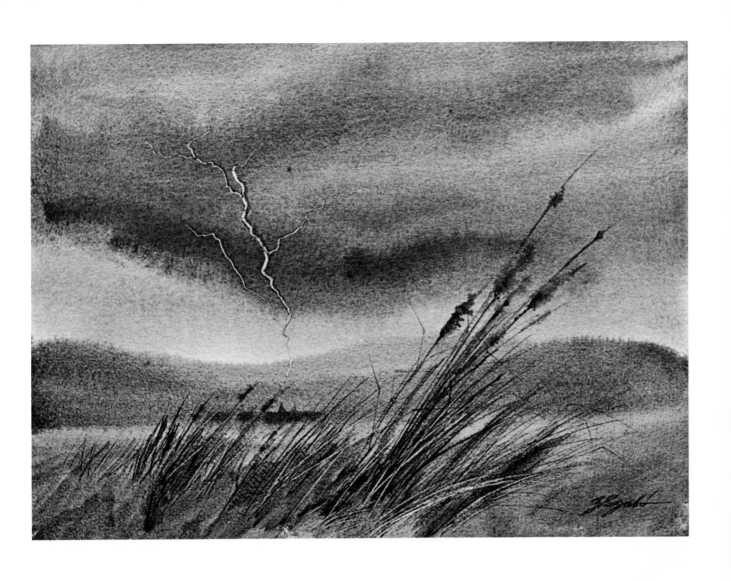

Step 3. For a finishing touch, I add some knifescrapes for the whitened blades
of grass.

Step 1. (300 lb. D'Arche's cold-pressed handmade paper.) I wet the bottom third of the paper. With a large brush, I define the boulder sharply on top and softly at the bottom where the paper is wet. With brisk brushstrokes, I paint in the lush grass at the bottom of the composition.

Step 2. I wet the top third of the paper and whisk in a light wash to indicate the sky. After the wash dries to a dull finish, I gently press a damp clean sponge down on the rock, lifting off some of the paint. After completed drying, I dab the sponge, full of strong color, on the mossy stone to add to the mottled effect. Using a small sponge, I also add some blue in the grass.

Step 3. Strong sponge-dabs of browns and reds above the rock indicate the shape of the tree. With a painting knife, I draw in a few branches for definition. Using a fine brush, I finish the blue flowers and the fine, tall weeds which complete the painting.

Step 1. (Heavy-grade rice paper.) With a soft, wide 1″ brush, I stroke in several hazy washes for the sky. With a painting knife, I paint a hint of the distant evergreens as well as my center of interest, the spruce tree.

Step 2. With a smaller brush, I add more distant trees and finish the larger spruce. Following this, I drybrush the thick weeds next to the spruce and wash in some light blue dips in the middleground snow. Using a painting knife, I add some larger weeds to the foreground.

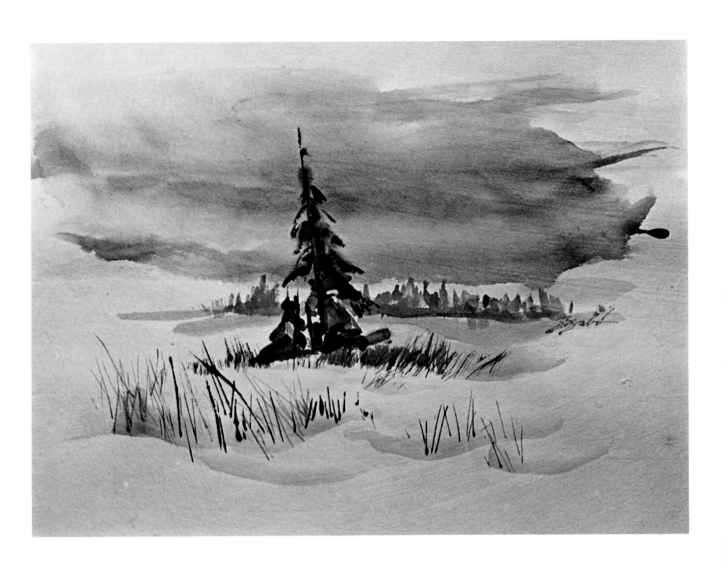

Step 3. A few light, soft brushstrokes give form to the unifying shadows in the foreground snow. The addition of some weeds finishes the job.

Step 1. (140 lb. D'Arche's hard-finished print paper.) All the painting is done on a sensitized offset plate. First I wet the surface of the plate, then I apply the paint for the moody cloud effect and for the red hair of the sleeping goddess of the volcano. I also paint the black volcano with red lava flowing out of its mouth. After the plate dries, I make the first impression with the press on a limp, presoaked paper. With a damp sable brush, I carefully wipe off the face of the goddess. Each time I touch the plate with my brush, I blot off the resultant moisture with a tissue held in the other hand. I do this until all the paint is removed from her face.

Step 2. After I remove the plate from the press, it has enough color left on it to show the image as it was in Step 1. This allows me to work in perfect register for each step. I add a sparkling halo about the goddess' head and leaping flames to the mouth of the volcano. Last, I darken the already angry-looking sky. I repeat the printing process using masking-tape guides to re-align the plate with the first impression.

Step 3. After carefully studying this impression on the paper, I connect the volcano and the sleeping goddess with a few touches of flame, including her eyelash. After the paint dries on the plate again, I print one more impression to finish the work.

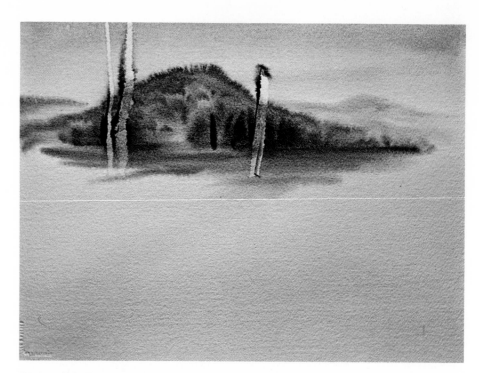

Step 1. (300 lb. D'Arche's cold-pressed handmade paper.) First I wet the paper. Then using a bristle brush, I establish the misty, forest-covered shore hills. After this wash dries to a dull finish but is still damp, I scrape out the three tree shapes with a pocketknife, pressing it hard and holding it as if I were spreading butter.

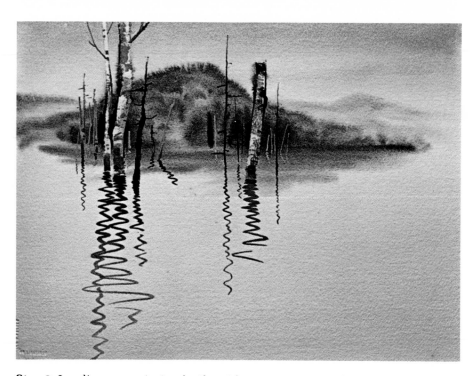

Step 2. Loading my painting knife with opaque watercolor, I paint the other flooded trees. Using a medium-size sable brush, I paint the trees' reflections with a diluted wash. For the rough bark on the three dead birches, I use thick, opaque watercolor.

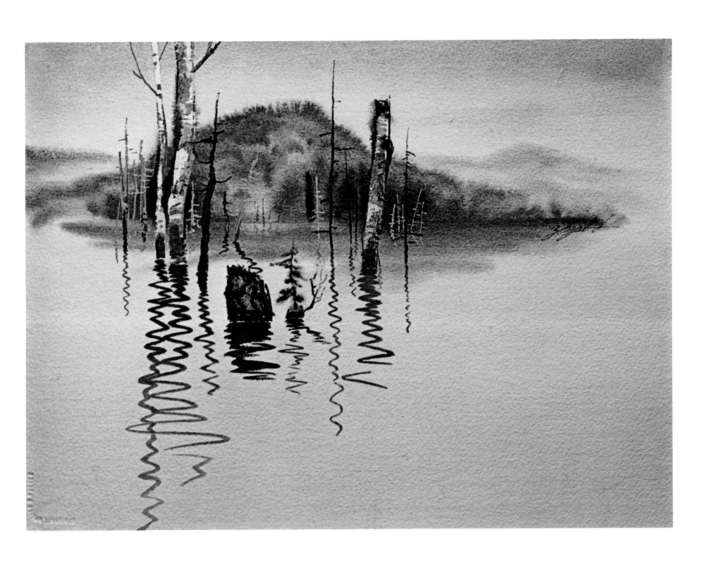

Step 3. I paint the large stump and add final touches to the trees with a pastel stick dipped in water. I wet the paper and then draw in the little green spruce growing out of the dead stump. Both the damp pastel stick and the pastel drawn on wet paper produce a soft, slightly blurred effect. Finally, I paint in the remaining reflections.

**Watercolor
on Smooth Paper
(Project 17)**

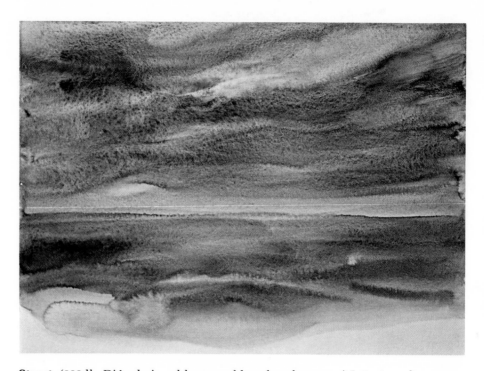

Step 1. (300 lb. D'Arche's cold-pressed handmade paper.) I start on dry paper. Using a flat, soft 1″ brush, I apply loads of browns and blues to the sky area, allowing the washes to blend freely. With similarly vigorous strokes but fewer colors, I paint the choppy water in the foreground. To prevent the paint from blending at the horizon, I simply use less moisture in my brush.

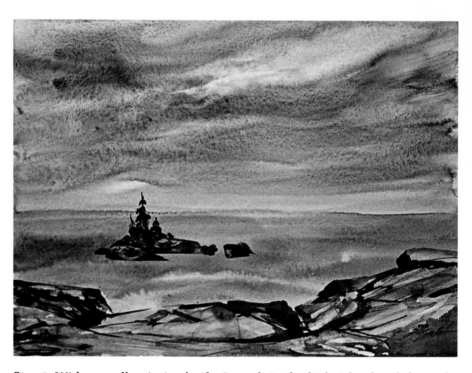

Step 2. With a small painting knife, I rough in the little island and the rocky shore in the foreground.

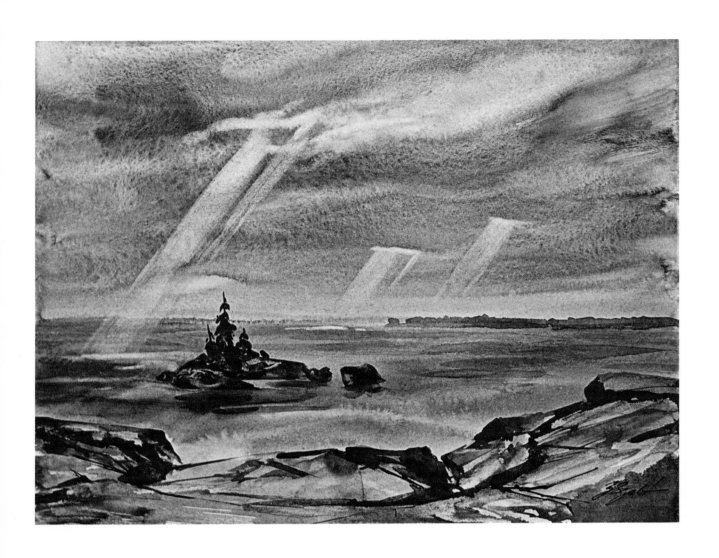

Step 3. I darken the waves around the island and add final details to both the close and distant rocks. For the sun's rays, I moisten the dry paint with a single brushstroke of clear water and then blot up the damp paint. The direction of the brushmark indicates the angle of the sun's rays.

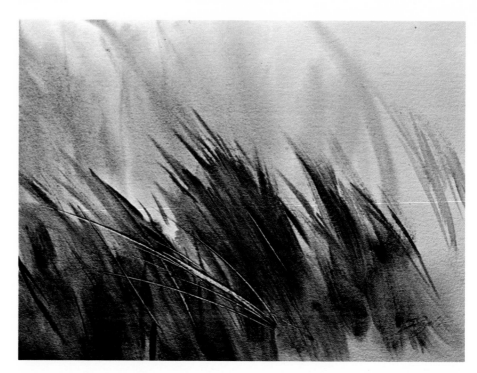

Step 1. (300 lb. D'Arche's cold-pressed handmade paper.) Using a flat, soft 1″ brush, I apply some light washes of mixed greens to the wet paper. I rub a soap bar with a 1″ bristle brush and then pick up a rich load of paint, mixing it well into the soapy brush. I apply this mixture to the wet surface for the tall, grassy weeds; as you can see, the paint doesn't ooze away but stays where I put it. I repeat this process until the grass is clearly established. I even pull a few light knife strokes into the damp paint for the whitened grass blades.

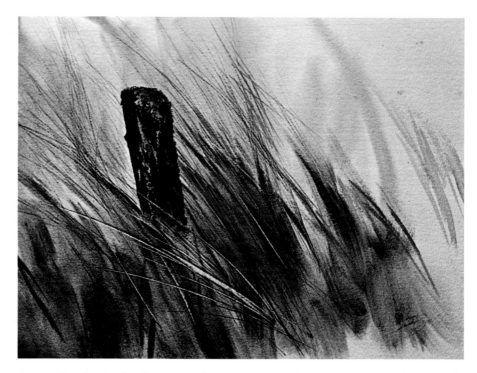

Step 2. I paint in the fencepost for my center of interest, using a dark wash. After it dries, I brush on the wood texture and the moss. For further definition, I add some fine grass to the composition.

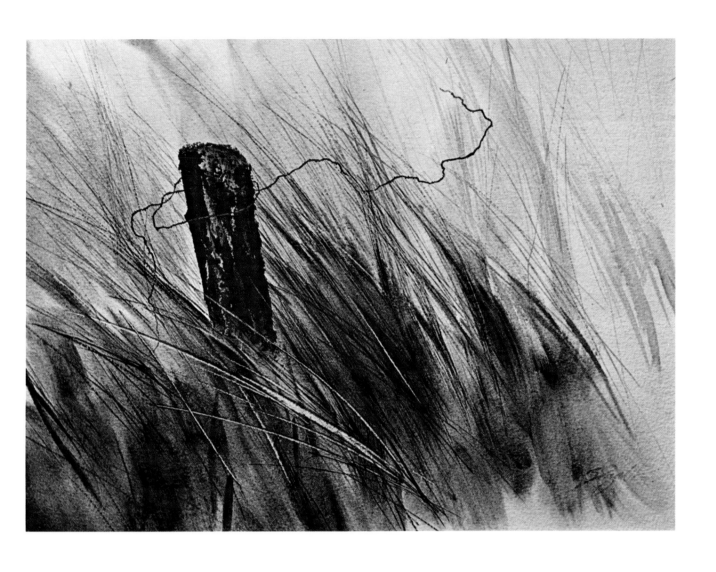

Step 3. Last comes the windblown wire for a touch of storylike quality.

Step 1. (Heavyweight, good-quality tracing paper.) Using a painting knife, I draw in the young trees. I align the bottoms of the trees with a loose paper mask; the resulting outline serves as the edge of the distant hill. I also sketch some weeds into the foreground.

Step 2. Still using the painting knife, I add a few more trees along the hill line, a large tree in the middleground, and more weeds in the foreground. With a small sable brush, I sprinkle the dry leaves on the trees and a few on the grass.

Step 3. I turn the paper around and paint a heavy blue wash above the hill's edge on the backside of the paper, using the bottom of the trees as a guideline. After this wash dries, I turn the paper around again to the front. The blue wash on the reverse side now looks paler and just right.

Wash and Line (Project 22)

Step 1. (300 lb. D'Arche's cold-pressed handmade paper.) I wet the paper. Using a bristle brush, I paint the edge of the distant forest with a light wash. Then, using the tip of the brush handle, I scrape a few trees into this area. While the paper is still wet, I stroke on soft, rippling washes to indicate deep snowdrifts.

Step 2. Using my painting knife, I carefully draw the old, half-buried fence. I brush on a deeper blue wash to further define the foreground snow drift. Again using the painting knife, I accent the distant drifts with a few light lines and also draw some more young trees into the background.

Step 3. Using a rounded sable brush, I rough in the larger tree. For a last touch, I use my painting knife to add detail to the tree as well as to sketch in the bent, frozen weeds.

Step 1. (300 lb. D'Arche's cold-pressed handmade paper.) First, I mask out the sun with liquid latex. After it dries, I wet the paper. Using a flat, soft 1″ brush richly loaded with blue, red, and orange inks, I stroke in the brilliant sky.

Step 2. After Step 1 dries, I peel off the latex mask, exposing the white circle which will be the sun. With quick strokes of strong red ink, I paint over the lower edge of the sky, right through the sun. A stroke of brown madder across the glowing red sun indicates a passing cloud.

Step 3. To complete the composition, I shade in the foreground with rich, dark washes, and silhouette some lacy trees against the horizon.

Step 1. (Dark brown, heavy mat board.) With a richly loaded, soft 1″ brush, I wash in the sky and water area. To optimize the influence of a dark paper background, I use *well-diluted* opaque watercolor. I give careful attention to painting the land just visible on the horizon.

Step 2. Using a painting knife and drybrush strokes, I paint the little island. For the island's lazy reflection in the water, I use a large, flat, soft brush and short, sidewise strokes.

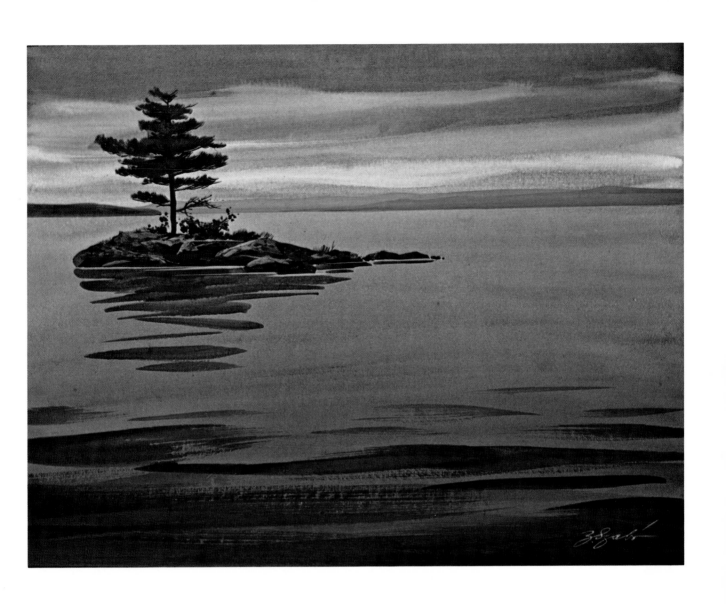

Step 3. To increase the three-dimensional illusion, I stroke in the dark blue waves in the immediate foreground and also add the distant promontory on the left of the horizon.

Step 1. (300 lb. D'Arche's cold-pressed handmade paper.) For the background, I use my painting knife to draw several leafless trees standing in deep snow.

Step 2. After Step 1 dries, I use a wide, soft brush to gently wash well-diluted, opaque white watercolor across all the trees. I blot some of the white paint off the larger trees to make them look closer.

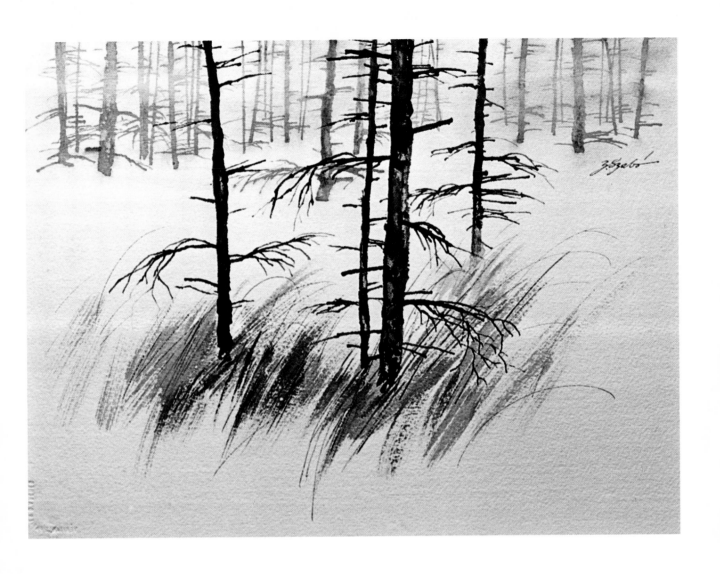

Step 3. To complete the illusion of color perspective, I include a few well-defined trees in the foreground that are richer in color than the distant trees. For a final touch, I drybrush in the grass.

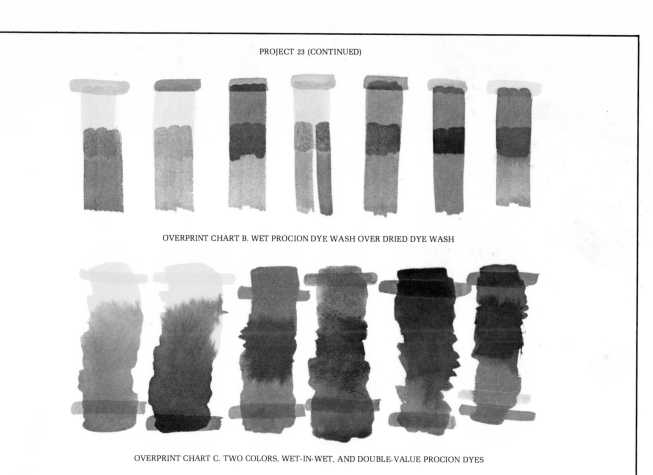

OVERPRINT CHART B. WET PROCION DYE WASH OVER DRIED DYE WASH

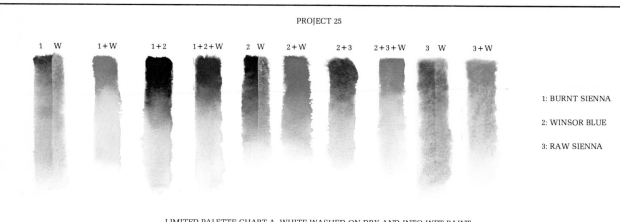

OVERPRINT CHART C. TWO COLORS, WET-IN-WET, AND DOUBLE-VALUE PROCION DYES

PROJECT 25

| 1 W | 1+W | 1+2 | 1+2+W | 2 W | 2+W | 2+3 | 2+3+W | 3 W | 3+W |

1: BURNT SIENNA

2: WINSOR BLUE

3: RAW SIENNA

LIMITED PALETTE CHART A. WHITE WASHED ON DRY AND INTO WET PAINT

PROJECT 26

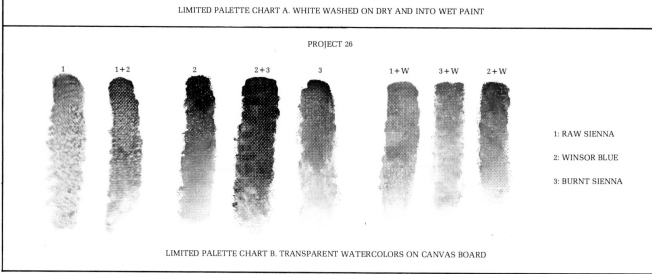

| 1 | 1+2 | 2 | 2+3 | 3 | 1+W | 3+W | 2+W |

1: RAW SIENNA

2: WINSOR BLUE

3: BURNT SIENNA

LIMITED PALETTE CHART B. TRANSPARENT WATERCOLORS ON CANVAS BOARD

15. AQUAGRAPH PRINTS

The term "aquagraph" is not a particularly original one, but it does express the nature of a process very well; the execution of a print in an aqueous medium—watercolor. Instead of painting on a sheet of paper, you paint on a metal plate and make a single print from that plate on moist paper. The aquagraph is done in several steps. First you apply color to the plate and print the color on the paper with the aid of an etching press. Then you apply more color to the plate and pass the paper through the press again. You repeat the process until you have the finished picture—which is the result of a series of *impressions* or color transfers from plate to paper.

Because you get only one print, you might ask why paint on the plate and transfer the color to the paper? Why not paint directly on the paper itself? If you paint a watercolor in a long, elaborate series of layers, you run the risk of ending up with an overworked, muddy mess. Each layer may disturb and possibly dissolve the color underneath it. The aquagraph process allows you to apply many separate layers of color to paper without dissolving the dry color already on the sheet.

Materials

1. Your transparent tube watercolors, brushes, and watercolor paper.

2. Lightweight paper. A 72 lb. paper or less will do. Any high quality, all-rag printmaking paper—the kind used for etchings and lithographs—also works well.

3. A piece of aluminum litho plate to paint on.

4. Masking tape.

5. A sheet of cardboard.

6. An etching press.

Any commercial offset printer will give you a used plate. The largest practical size for an aquagraph is about 16″ x 20″, though your own plate size will depend upon the size of the press you have available. Obviously, some press beds are larger than others.

To cut the plate to the exact size you need, use a heavy knife—like a Stanley mat knife—and a straight edge. Score the plate in a line several times until it is cut, very much as you would cut heavy cardboard.

Smooth the sharp edge with a file or sandpaper so the plate won't cut your finger or damage the paper under the pressure of the press.

The plate has a shiny side and a matt side. Paint on the matt side, which is designed to hold moisture.

Visualizing Your Picture

Bear in mind that the printed image on the paper will face in the opposite direction from the image you paint on the plate. If you have difficulty visualizing the final picture as you paint, place a small hand mirror to one side of the plate and periodically look at the mirror to follow your progress.

The safest procedure is to work from light to dark and from cool colors to warm. Apply your palest and coolest tones to the plate first. Let the plate dry. Place it on the bed of the press, face up. Make marks with a soft pencil on the press bed, indicating the location of the four corners of the plate; you'll then be able to put the plate in the same position each time you add color.

Preparing Your Paper

Now prepare your paper for printing. Cut the paper large enough to allow a generous border around the printed image, let's say 3″ larger than the plate all the way around. Soak your paper in cold water. The sink will do for small pieces of paper; you use the bathtub for large sheets.

While the paper is soaking, make marks on the press bed to indicate where the paper will fit. Assuming that the paper is 3″ larger than the plate on all sides, you can draw lines on the press bed denoting these margins. Stick a strip of masking tape along the top line and another strip along one side; be sure that the tape is *outside* the 3″ border, not within it. This will give you a large, inverted L into which you can fit the paper for each impression.

Take the paper out of the water and lay it on an absorbent pad, composed of a stack of newspapers with a paper towel on top. Carefully remove the excess water from the surface of the paper by dabbing it with a cleansing tissue until the shine disappears. Do the same thing to the other side of the sheet until the surface is no longer wet, but damp and limp.

Placing the Paper

Now you are ready to print. Hold the sheet at an angle above the press bed so that the paper does not touch the plate until the edges are firmly fitted inside the tape. Then place the top edge and one side of the paper against the inside of the inverted L of the masking tape. Hold the paper edge down beside the tape with one hand and use the other to guide the paper down over the plate. Be sure that neither the paper nor the plate moves from this position.

Turning the Crank

Put a sheet of medium-weight cardboard over the paper so that the metal roller of the press will not touch the wet sheet. Turn the crank of the press and run the plate, paper, and cardboard through together. One pass through the press is enough; a second pass will squeeze too much moisture out of the paper. Remove the cardboard and then peel away the paper. Place the paper between sheets of plastic, foil, or glass to keep it moist while you are adding more color to the plate.

Remove the plate from the press bed. Using a wet cleansing tissue, wipe away the color that is still on the plate. A faint residue from the first color application will remain as a guide for your additional color applications, but it will not print when the plate is returned to the press. Begin to add your middle tones, both warm and cool, with more detail.

Repeating the Process

Repeat the printing process I have just described. Use the masking tape guides when you replace the paper on the press. Use a fresh, dry cardboard to protect the paper each time you go back to the press. You now know the basic procedure. Continue to add color—working toward your warmer and darker tones.

Keeping the Paper Moist

If you go back to the press more than three times with the same sheet of paper, the sheet will begin to dry up. To keep the paper moist, place it face down on an immaculately clean, dry surface, and spray the back with a light mist of clear water from an atomizer. Watch the water as it soaks into the surface and make sure no shine develops; if it does, you've applied too much water. When that happens, wait until the shine disappears before you pick up the paper for painting.

If the paper is too dry when it goes through the press, not enough color will be transferred from the plate. Check for dryness by peeling back the corner of the paper from the plate before you remove the entire sheet. If the paper has picked up too little color, moisten the back of the sheet—while it's still in position on the press—with the atomizer and then pass plate, paper, and cardboard back through the press.

For the demonstration of *Aquagraph Prints* see the color plates on pages 94–95.

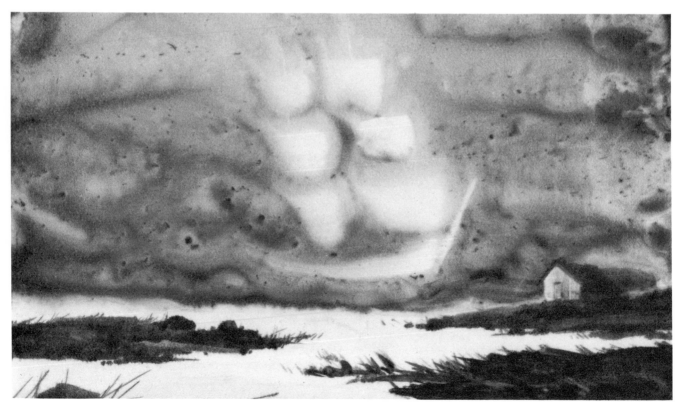

THE GHOSTSHIP OF MAHONE BAY, N.S., AN AQUAGRAPH PRINT EXECUTED WITH REGULAR WATERCOLOR PIGMENTS AND WATERCOLOR PAPER

16. Mixed Media

When you work with a mixture of medias, the principal thing to keep in mind is order. You must know what ideal sequence is to achieve the best technical results. The most important advice I can give you here, however, is to use only those materials with which you are familiar. Knowing their individual qualities will save you time that you can use to better creative advantage.

Materials

1. Your transparent and opaque watercolor tubes.

2. Soft-haired and bristle brushes.

3. High-quality rag paper.

4. Two acrylic brushes.

5. A few acrylic colors.

6. A *small* set of soft pastels.

7. Matt finish acrylic spray.

8. A small bottle of acrylic media.

9. Tube of Aquapasto watercolor painting medium.

Starting with Pastels

I'd like to start you with ordinary pastel sticks because these pigments mix well with water. You can't use oil pastels the same way because their oil content repels water. Work with either the round, soft, pastel sticks or the square ones made for layout work. In illustration A, I've used the latter, which are a little harder and less crumbly. I have wet part of the paper and, with firm pressure, drawn a line starting from a dry area and continuing into the wet space. The sketch of the apple tree shows how compatible pastel is with watercolor. The foliage and the grass are painted with transparent watercolor, and while the paper is still saturated with water I draw in the trunk, branches, and the apples. Because the pastel is crumbly, it will dry back to its original consistency—and smear if you touch it. As a precaution, therefore, you must spray your work with a protective acrylic fixative. The fixative won't affect your watercolor, but it will stabilize the pastel.

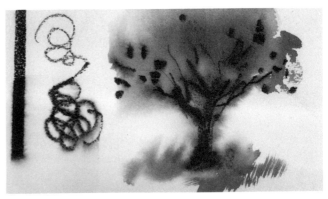

A. WATERCOLOR AND PASTEL

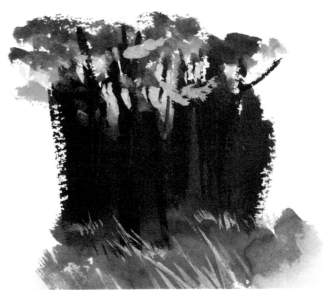

B. CASEIN TEMPERA

Using Casein Tempera

Opaque watercolor and casein tempera usually mean the same thing. Except for their opacity, they behave very much like transparent watercolor. If you use casein tempera in a thick consistency, you can paint white on black if the black is dry. In my illustration B, you can see how well the light colors survive over the dark ones. It also shows how well casein tempera spreads on wet paper. If you use it in a thin consistency it can look and behave exactly like transparent watercolor. It even wipes off after drying.

115

Painting with Aquapasto

Only recently, Winsor & Newton came out with a new product called Aquapasto. It is a water-soluble, colorless gel designed to mix with transparent watercolor. If you use it with a brush, it'll leave brushmarks (C). With your painting knife it spreads beautifully, leaving a thin or heavy impasto depending on how you hold your knife and how much pressure you exert on it. Aquapasto will stay transparent even when thick, and you can rework it after it dries by simply wetting it. In short, it's great fun to work with.

Experimenting with Acrylic

Acrylic paint is a powerful medium of its own, as I'm sure you're aware. Using it in combination with other media will demand a little experiment. Remember that after acrylic dries it will no longer dissolve. This means you must plan your modeling to make sure your acrylic paint doesn't dry too soon. It can be applied to practically any surface—including surfaces covered with pastel or watercolor (D). You can work pastel on top of acrylic, but you can't apply *watercolor* to dry acrylic. It won't adhere.

Planning Your Approach

After you have familiarized yourself with these graphic materials, work with them in combination with one another. Plan your approach carefully and try to leave acrylic to the end. Use a mixed technique as a complement to, not a substitute for, watercolor. Be subtle. The finished result must be an esthetic unit, not a hodgepodge of unrelated bits of color.

For the demonstration of *Mixed Media* see the color plates on pages 96–97.

C. AQUAPASTO WITH BRUSH (TOP), WITH KNIFE (BOTTOM)

D. ACRYLIC OVER PASTEL (LEFT), PASTEL OVER ACRYLIC (RIGHT)

17. Watercolor on Smooth Paper

Most commercially made papers are relatively smooth. For experimental purposes, any one of them should give you an opportunity to learn. However, they *all* differ slightly in behavior. Cheap pulp papers will not stand up to a painter's treatment. Buy all-rag, hard-surfaced paper. For the following illustrations, I have chosen D'Arches 300-lb., hot-pressed paper. Its performance is superb.

Materials

1. Your usual transparent watercolors.

2. Bristle and soft-haired brushes.

3. A painting knife.

4. Heavyweight, high-quality smooth paper. It should be 100% rag, hot-pressed paper. D'Arches, Strathmore, and Crescent are a few popular names in papermaking.

Here are a few hints about paper characteristics: the smoother your watercolor paper is, the stronger your color will remain after it dries. Rough watercolor paper is soft and absorbs a lot of water; hot-pressed paper, on the other hand, is hard and not very absorbent. Also, you can remove the paint from the surface of smooth paper a little easier than you can from rough paper. All you have to do is wipe it—either while it's damp or after it has dried. One further hint: the smoother the paper the faster it dries. Even so, be on your guard about large washes collecting in pools; pools increase the risk of hard edges (backruns) forming on their borders.

Starting on Dry Paper

Begin watercoloring on smooth paper by trying a direct approach of washes on dry paper (A). Don't worry about accidents! They'll happen every time. Accidents are part of the charm of watercolor, and they indicate a degree of daring on your part.

Working on Wet Paper

Now wet the next paper thoroughly (B). Apply your wet washes without hesitation because the paper's

A. DRY SMOOTH PAPER

B. WET SMOOTH PAPER

smooth surface dries quite rapidly. As your wash starts drying, you'll probably notice that the grainy colors tend to separate, creating a lovely pattern. This pattern helps to add interest to an otherwise monotonous wash. Lighter washes tend to show patterns better than darker ones because the more water the wash contains the greater the flowing action it creates.

Using Both Sides

If you've been drybrushing your edges, you must find other methods on smooth paper (C). You have to define foliage and other lacy edges a little more carefully with the brush. Paint the next exercise on both sides of the same paper, remembering, of course, that the front and back side of every paper behave a little differently. I've cut two strips from my paper, turned one

back to front, and placed it adjacent to the other one, and taped them together on the reverse side. I want to illustrate for you the behavior of the knife (D). The birch trunks are scraped off with my pocketknife and the blades of light grass with my painting knife. I hold them both as though I'm spreading butter. I use my little painting knife exclusively to paint the single birch tree on the right side of the illustration. As you can see, the dry surface of the paper responds beautifully to the knife techniques.

You'll achieve fine results quickly on smooth paper, but you won't have time to hesitate. Take all the time in the world to plan your steps, but once you begin you must paint rapidly to obtain freshness.

For the demonstration of *Watercolor on Smooth Paper* see the color plates on pages 98–99.

C. DETAIL ON SMOOTH PAPER

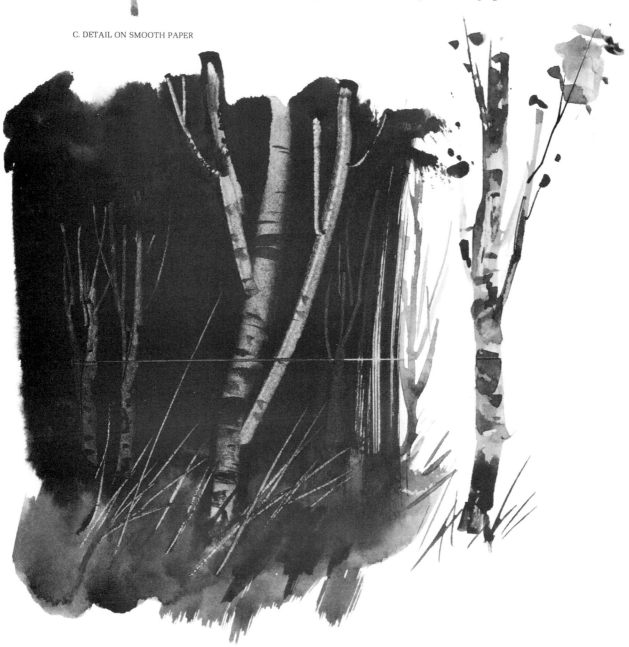

D. KNIFE ON GRAINY SIDE (TOP PART OF ILLUSTRATION), ON SMOOTH SIDE (BOTTOM PART)

18. Soap with Watercolor

Soap has a limited usefulness for a watercolor painter—but it does a few wonderful things. Its essential function to me is to make wild wet washes behave.

Materials

1. Your transparent watercolors and brushes.

2. At least one sheet each of cold-pressed and hot-pressed handmade watercolor paper.

3. One bar of colorless soap. Pure castile soap is best, but any household soap will do the job.

For the following exercises I suggest you use a ½″ wide bristle brush for quick results. Soap softens the color value somewhat, and a bristle brush picks up more concentrated pigment than a soft one does. It also leaves more exciting, better defined brushmarks. After all, texture is a vital factor in watercolor.

Experimenting with Soap

Don't mix soap into your regular colors on your palette; it's a nuisance to clean it out later. Use a separate washable surface for mixing. Put plenty of wet pigment on your brush first, and then scrub the soap bar with it to allow the soap to mix with your paint. Make a brushstroke or two on a dry part of your paper. Then pick up more soapy pigment and paint it into a wet area. Note that your soap wash doesn't spread wildly, the way a wash would with just straight paint and water. Now cover a fair size area of your paper surface with a rich, dark, regular wash. Sepia will do fine. Load your brush with a lighter soap wash—burnt sienna, for example—and quickly brush it into the wet, dark wash. You'll see that your light color will survive without oozing too far and that the dark color immediately next to the light wash will turn lighter, creating a halo effect. This, too, is the nature of the soap technique (A).

Comparing Washes and Paper

After you complete this experiment, brush a light and dark soap wash onto a piece of wet, rough paper and then onto a piece of wet, smooth paper (B). Observe how well the brushmarks survive—along with the accidental little bubbles. You won't see much difference between the two papers, but there'll be some nonetheless.

Achieving a Texture

You can dab soapy paint into a wet wash just as easily as you can paint in a brushstroke. The resulting texture is hard to identify, but very useful for certain effects (C).

Testing for Adhesiveness

Paint a dark wash on your paper and then next to it, using the same pigment, do a dark soap wash (D). After they dry lay two strips of paper on top of each wash, leaving a gap between the pairs of strips. With a bristle brush scrub the exposed surfaces until the pigment looks wet and loose. Remove the paper strips and quickly blot up the loose paint. A light line will result on each wash, but you should note that the same amount of scrubbing will remove more paint from the regular wash than from the soap wash. This difference suggests that soap has an adhesive quality that can be very useful.

Soap washes, for example, can serve the purpose of masking. First, paint a thick soap wash of light color over an area on your paper that you want to leave light. After it dries, paint your dark wash right over it. When that dries, gently apply clean water with a soft brush over the soap-covered surface and blot up the loose, wet surface paint with a tissue. Repeat this process until the tone of the soap-masked area is just right. Note the bottom part of the No Trespassing sign; the top half shows a dried dark wash on top of a soap wash (E).

After you finish your picture, don't forget to wipe your soap bar clean with a wet tissue. It's a handy object to have ready for use.

For the demonstration of *Soap with Watercolor* see the color plates on pages 100–101.

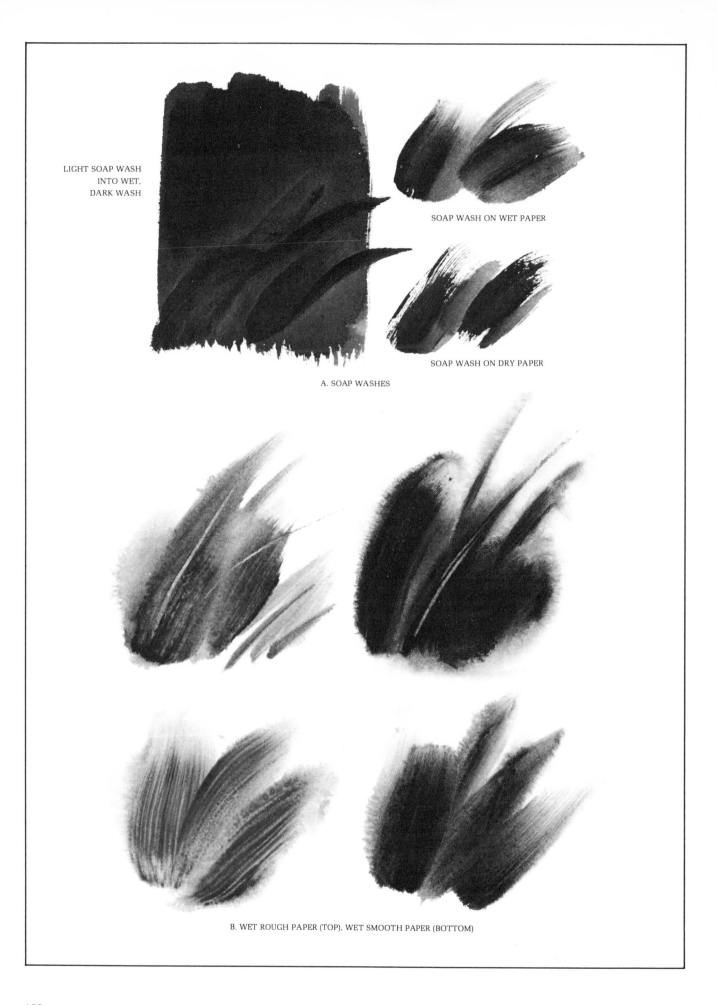

LIGHT SOAP WASH
INTO WET,
DARK WASH

SOAP WASH ON WET PAPER

SOAP WASH ON DRY PAPER

A. SOAP WASHES

B. WET ROUGH PAPER (TOP), WET SMOOTH PAPER (BOTTOM)

C. SOAPY PAINT DABBED INTO WET WASH

D. REGULAR WASH (LEFT), SOAP WASH (RIGHT)

E. MASKING EFFECT OF SOAP WASH

19. Watercolor on Translucent Materials

When you work on a translucent surface, you must concentrate on creating a refined balance of *delicate values*. Your paint is transparent, and now the paper—or the parchment, or the glass—is too. How good your painting will be depends on how successfully you are able to control light tones.

Materials

1. Your regular watercolors and brushes.

2. A few sheets of good tracing paper, the heavier the better.

3. A small sheet of Mylar. Mylar feels like paper, but it's a plastic product. Companies that supply tracing papers for draftsmen usually stock it.

Because you're using a translucent paper, you can paint on the reverse side without interfering with the front side. The value of your color on the reverse side, however, will be lighter because of the fogging quality of the paper. The more transparent your paper, the stronger the color will remain. When the water on your brush comes in contact with the paper, you'll also be confronted with buckling, of course. To minimize this wrinkling, use the heaviest tracing paper available.

To give your finished work more of a light-reflecting quality, you must display it with white paper behind it. If you want your painting to present a dull mood, however, simply place it on a darker background.

Testing for Transparency

Now take a piece of your tracing paper and paint a smooth cover wash of one primary color on the front of it and another on the reverse side, partly behind the first wash. Let them dry. The overlapping area should be a dull secondary color. I've used yellow and blue and got green (A). On the front side paint a wash of the second color over a dry part of the first one. This, too, will result in the same secondary color. It will be stronger, though, because the paper is not between the two colors, diffusing the one on the back. With this exercise you can demonstrate visually how transparent your paper is—before you start working on it.

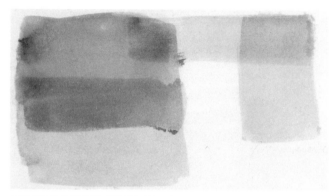

A. WASHES ON FRONT AND REVERSE OF TRANSLUCENT PAPER

Painting Two Landscapes

Paint a *simple* landscape with two colors (B). Use them on the reverse side of your translucent paper as well. Wherever the two paintings overlap, you'll have an interesting combination of values. The more complex your paintings, the more varied will be the outcome.

Using Your Knife

You can also have a lot of fun using your painting knife imaginatively on the front of your white tracing paper (C). If you feel the need of a soft background complement, turn it over after it dries and paint on the required washes.

Working with Mylar

A highly transparent material—called Mylar—is now available. It has the unique quality of remaining flat even after being rolled up for a prolonged period. Before you paint on it, make sure you wash it clean of fingerprints or any other marks. Experiment with Mylar by painting your watercolor washes on it when its surface is wet and dry (D). Use both the front and the reverse side. The colors will appear very close in value because the film between the two sides is much more transparent than that of tracing paper.

Now try a little design, using your painting knife on Mylar. The action and behavior of the paint, though a little temperamental, will offer you some fresh results. Again, take advantage of the reverse side for an added complement to your composition. To protect the paintings on these smooth materials, you can spray them with acrylic fixative (E).

Trying Other Materials

Try painting on parchment and frosted glass. They're but two more of many usable surfaces. Experiment with other materials as well, choosing the one most suitable to your need.

For the demonstration of *Watercolor on Translucent Materials* see the color plates on pages 102–103.

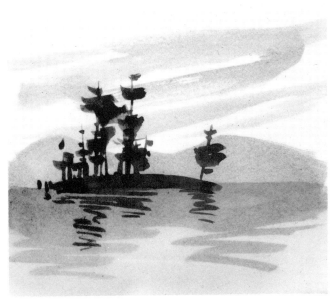
B. LANDSCAPE ON TRANSLUCENT PAPER

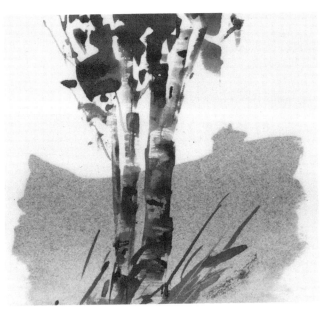
C. PAINTING KNIFE ON FRONT, WASH ON REVERSE

D. MYLAR FILM

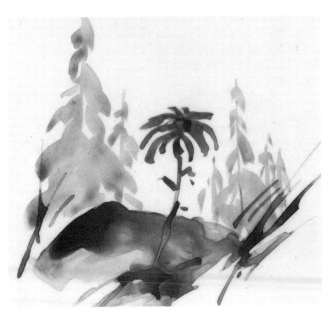
E. PAINTING KNIFE ON MYLAR

20. Watercolor Collage

A watercolor collage can be interpreted in several ways. For example, your painting can give the *effect* of a collage, or fragments of material can actually be adhered to the picture's surface. In this chapter, I shall discuss both the effect and the actuality.

Materials

1. Your familiar palette of watercolors, brushes, and a sheet of watercolor paper.

2. Pieces of fabric: cotton, linen, raw silk, burlap.

3. A can of spray fixative.

4. J-cloth (Handi-Wipe, or any of the strong, "waffle"-textured paper towels used for dishwashing and cleaning purposes).

5. Textured and thin Japanese paper.

6. Lots of tissue paper.

7. One small, hard-surfaced roller. for convenience.

Using the Surface of Fabrics

Impressions taken from the woven surface of fabric offer a wonderful variety of patterns. I have used a few common types to show you what I mean (A). If you dip the dry cloth into a prepared pool of color and transfer it to paper, you'll get a weaker impression than if you brush the paint onto the material with a bristle brush and then transfer it the same way.

Holding Strips of Paper

Another way of creating a watercolor collage is to hold loose strips of paper, which will act as masking material on your painting surface and brush your paint around them. Don't move the paper while you paint or it will smear the edges of your painted area. You can hold two strips of paper beside each other, and in the narrow gap between brush on your watercolor. In my illustration B, I am using one color in several layers and a strip of paper. The stipple effect was achieved with a sponge.

In my next exercise, for the painting of trees (C), I brush dark brown watercolor onto a strip of J-cloth, press the damp surface over the fence area, and rub my finger over the cloth, making a gentle impression. I use my brush for the support poles and the bird.

Transferring a Print

To transfer a print, dip your textured material (cloth) into a prepared wash, place it on top of your painting surface, painted side down, and press on it gently with your hand or a small, hard roller. Maintain pressure until the paint shows the strength you want.

Pressing the Brush Handle

I create a line pattern by dipping the wooden edge of my brush handle into wet paint and pressing it into my paper. I print the flower, one petal at a time, with a triangular shaped piece of paper (D).

Rolling a Handle

Another combination of approaches is employed in sketch E. The clouds are done with a bunched-up tissue. I dip the tissue into paint and stamp it vigorously on the surface of the paper until the texture looks right. To get the "industrial" effect I rotate the cylindrical handle of an etching tool in a wet wash, and then roll it onto my paper. As the wash loses strength it pushes little beads of paint further along, creating a granular effect. This requires hard pressure. The lower "drybrush" impressions are done in the same way but using a different color and less pressure. To get the smokelike wiggles, I drag the wet blob at the end of each stack with the corner of a soft strip of paper.

Removing Paint

You can achieve a collage effect on a wet wash by either transferring paint to it—or by removing paint from it. In illustration F I brush on a dark wash and remove the light mountain peak by blotting off the surplus color with a soft tissue. Similarly, I remove some of the paint behind the fence with a damp J-cloth; after the paper dries, I use dark blue paint to transfer a print with the same J-cloth. I use the edge of my brush handle for the poles and roll-print the dry brush at the bottom with the same round handle.

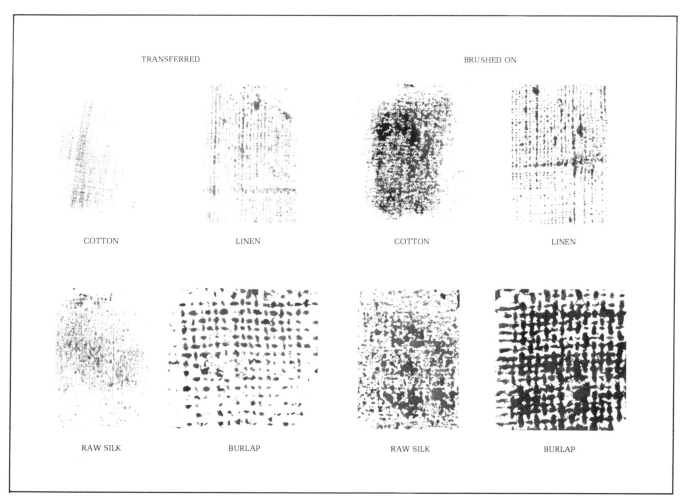

TRANSFERRED BRUSHED ON

COTTON LINEN COTTON LINEN

RAW SILK BURLAP RAW SILK BURLAP

A. IMPRESSIONS FROM FABRICS

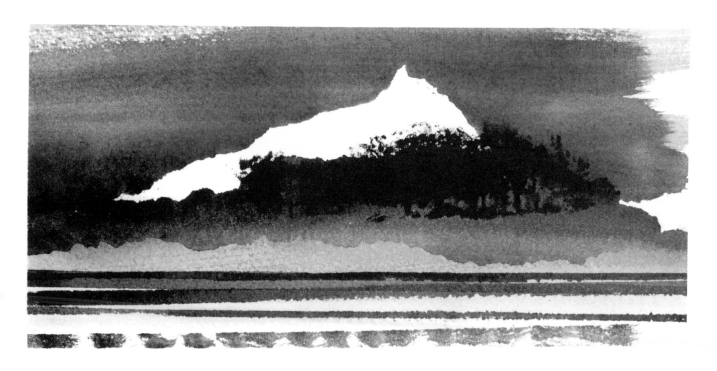

B. ONE COLOR IN SEVERAL LAYERS

C. J-CLOTH IMPRESSION

Adhering Pieces of Material

The third approach to developing a watercolor collage is to actually adhere pieces of water-receptive material to your painting surface, thereby creating texture. You can follow this process either before or after you apply paint. If your material is light enough—tissue or rice paper, for example—the glue in your watercolor is usually enough to keep it stuck to the paper. If you find the material uncooperative, use a compatible adhesive. I prefer starch or thinned-down mucilage or gum arabic.

In the top part of my little illustration G, I stick torn pieces of textured Japanese rice paper into a wet watercolor wash. I dip the bottom piece into paint and put the wet paper in position to dry. To place the white V-shaped tissue on top, I spray the whole surface with starch for adhesion. I transfer the color of the wires to the paper by dipping a thread into paint, placing it tightly on the surface, and pressing it down with a tissue. I use the edge of my brush handle for the pole and paint the birds with quick brushstrokes.

For a collage, you must be daring and test the extremes of your imagination. Anything goes—if it looks right and stays permanent.

D. BRUSH-HANDLE IMPRESSION

E. BRUSH HANDLE ROLLED

F. J-CLOTH BLOTTED

G. COLLAGE

Watercolor Collage

Step 1. (300 lb. D'Arche's cold-pressed handmade paper.) On a wet paper, I rough-brush in the distant misty rocks and the fisherman's hut. After this wash dries, I add still more texture to the background by dipping paper into paint and touching up the rocks. Using a ruler with paint on its edge, I print dark lines for the net-drying poles. To print the nets, I cut out crescent-shaped holes from wrapping paper and lay it loosely over my painting. Wherever the painting is exposed, I press on a piece of paint-soaked J-cloth (Handi-Wipe), continuing this process until the overlapping nets look right.

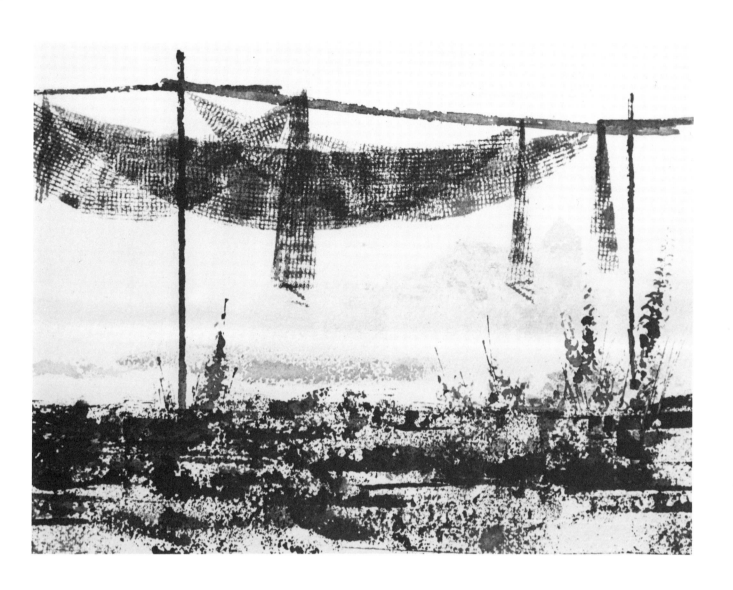

Step 2. I paint in the muddy foreground with pieces of paper dipped in paint and then pressed and smeared on the paper. I sketch in the tall weeds with a painting knife.

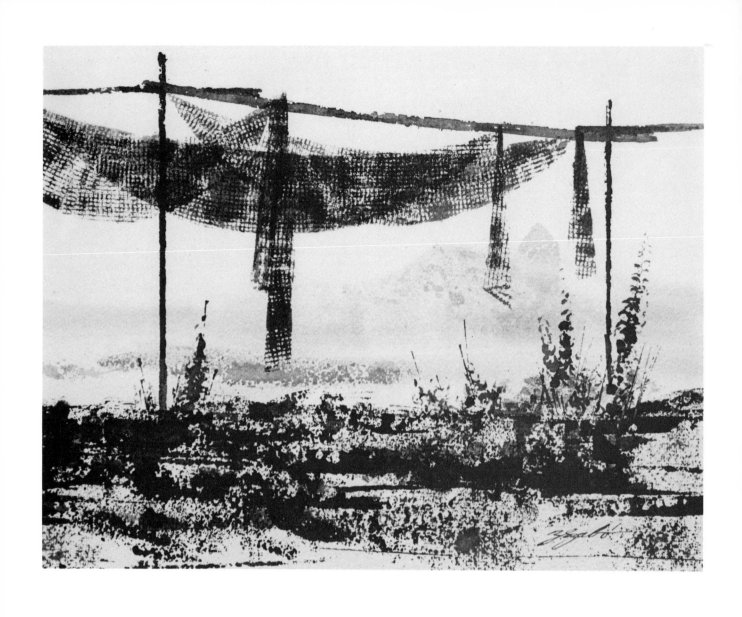

Step 3. I add the finishing touches to the nets, and the watercolor collage is completed.

21. Watercolor with Hard (Bristle) Brushes

Bristle brushes are firm but springy. They can pick up more concentrated paint faster than any soft-haired brush. For the vigorous application of watercolor, a bristle brush will serve you well.

Materials

1. Your watercolors.

2. One ½″ and one 1″ No. 1146 Grumbacher bristle brush or similar size oil-painting brushes.

3. Handmade watercolor paper.

4. A new No. 2 and No. 5 short-haired, oil-painting brush.

Making Essential Brushstrokes

First, I'd like to introduce you to one of my favorite painting tools: a crudely finished, inexpensive bristle brush made exclusively by Grumbacher—catalogue No. 1146. It's made with a slanted edge that is just right for making three essential brushstrokes. Illustration A shows you the shape of the brush as well as the three brushstrokes done on dry and wet cold-pressed D'Arches paper. The three numbers identify the side of the brush that made these strokes, and the arrows show the direction in which I pulled the brush.

Pushing the Brush

If you keep your paint dry in the wells of your palette like I do, the bristle brush will offer you instant action because it wets and picks up paint fast. In my sketch I've painted the forest with its variety of values with a ½″ slanted brush on wet D'Arches cold-pressed paper (B). After the paper dries I paint the "drybrush" grass not by pulling the brush naturally but by *pushing* its hair in the opposite direction from the handle.

Scrubbing with a Paintbrush

The small No. 2 oil-painting brush serves as a scrubber. It's capable of loosening dry paint. All you have to do is scrub the dry paint with the damp point of the brush and blot up the loose, moistened paint with a soft tissue. That's exactly what I do on the snow-cov-

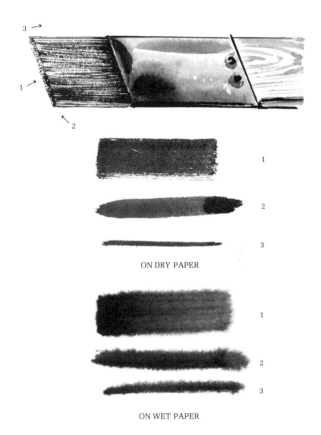

ON DRY PAPER

ON WET PAPER

A. SLANT-EDGE BRISTLE BRUSH AND BRUSHSTROKES

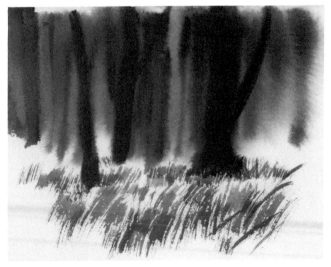

B. BRISTLE BRUSH ON WET (IN TREES) AND DRY (GRASS)

ered roof in illustration C. For the sharp white of the moon I use a paper mask, cutting the shape of the moon from a piece of paper. I hold the mask in position while I use my brush to scrub briskly the exposed moon-shape area. Lifting the mask quickly from the painting, I immediately blot off the loosened paint. For the faint circular continuation of the shaded side of the moon, I make one pass with the same damp scrubber and blot it up again.

Using a Slanted Brush

In the last illustration (D), I brush on the stump of the tree and then use my ½″ slanted brush for that seemingly insignificant weed. The important consideration here is the removal of the dark paint where the thin weed is in front of the stump. I cut a strip of paper in half on a curved line. I place one half with the curved edge where I want the weed to be located, hold it in position with my left hand, and put the other half down just a hairline away, holding it in position with my left thumb. With the two pieces of curved paper forming a mask, I then scrub away a light line for the weed in the same way I scrubbed away the moon in (C).

As you remove dry paint with your brush, some water is bound to seep under the edge of your paper mask. Don't worry about it. It's only sitting on top of your paint. If you act quickly when you blot the loosened pigment, your tissue will soak up this surplus water and it won't leave any mark. Don't press the tissue too hard and don't dillydally. As soon as you put down your scrubber, blot immediately. Speed is important.

C. SCRUBBING WITH BRUSH

D. SCRUBBING AROUND MASK

Watercolor with a Bristle Brush

Step 1. (300 lb. D'Arche's cold-pressed handmade paper.) I use a slanted-edge, 1″ bristle brush on dry paper to rough in the rich washes of grass and the basic value of the discarded boards and barn wall. To get that mottled effect in the grass, I use strong brushstrokes with lots of paint and little moisture; for the wispy grass in the foreground, I use light drybrush strokes.

Step 2. I add more drybrush definition to the grass and boards for texture. These improvements are subtle but extremely vital.

Step 3. Finally, I wet the sky area on the top left and stroke in a few blue hints of windswept clouds. After this dries, I silhouette some broken fence logs against the light sky to break the harsh edge of the grass.

22. Wash and Line

When most people think of wash-and-line watercolor technique, they think of transparent watercolor and India ink. But this is only one of many wash-and-line techniques. To me, it involves *any* line complementing watercolor. The technique is a combination of blending wash tones and solid lines that set off each other.

Materials

1. Your regular watercolors, brushes, and handmade paper.

2. One HB pencil.

3. One old-fashioned writing or drawing pen (nib and holder).

4. A painting knife.

5. One bottle of India ink.

6. An ordinary pocketknife.

7. A nail clipper.

Watercoloring with Pen

If you take a close look at the most common wash-and-line techniques, watercolor and India ink, you'll notice that the black of the ink contrasts best, and acts as a greater unifying force, when it's used with light value washes. Never try to camouflage or weaken this contrast. I've drawn the lines in illustration A with a playful application of a drawing nib. After the ink lines dry, I slap on the light washes with similar friskiness. You can take even greater advantage of your lines if you use well diluted watercolor in your nib instead of India ink. You don't have to dip your pen in the watercolor; you can pick up the paint with a brush and brush it onto your nib. And you can use several colors. There's also another advantage in making lines with diluted watercolor: after they've dried, you can soften them and add tone value by simply brushing over the lines with clear water (B).

Making Lines with Your Knife

Pen nibs are not the only tools you can use for drawing lines. Your painting knife is one of the best little help-

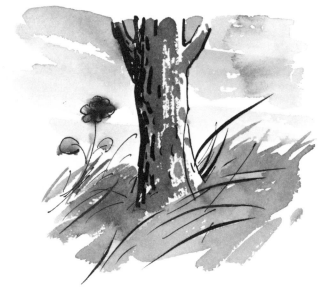

A. WASH AND INDIA INK

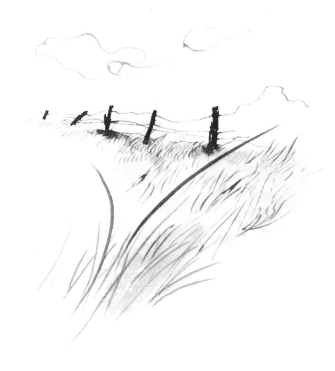

B. WATERCOLOR WITH PEN NIB

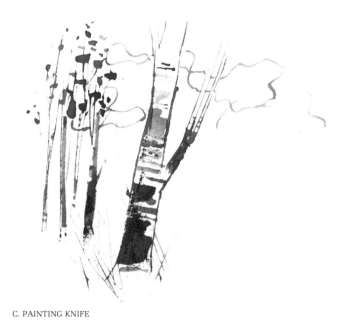

C. PAINTING KNIFE

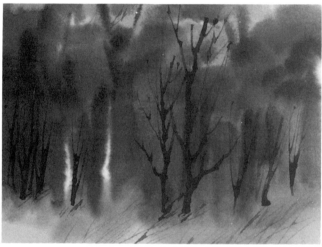

D. DRAG STROKES

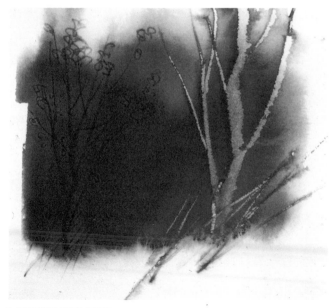

E. SCRAPING WITH KNIFE

ers you'll ever need. Not only can you use it for varied colors and tones, but you can paint your lines in different widths. In sketch C, I am using the broad side of my knife for the wide lines and the thin edge, pushing upward, to paint the thinner lines, like the edges of the trunk. I drag the knife point over the surface of the paper for the branches and clouds. To paint the little grass blades, I use the edge of the knife tip as though I were slashing with it. For the "drybrush" touch on the trunks, I use a thick paint and then smear it with the back, flat part of my knife.

Wiggling the Tip

Your knife is also capable of making loose lines on top of dry paint. In sketch D, I paint a rather vaguely defined forest on wet paper. It would be too indefinite without the dark trees and green touches in the foreground. To achieve these rich lines I hold my knife by the end of the handle and drag it backward, touching the paper only with the tip. I hold the handle lightly enough to allow it to wiggle as the tooth of the paper dictates. As the knife is loosing paint, the lines get thinner and finely fade away.

You can make effective lines not only on dry paper but on wet paper as well. You can draw into a wet wash with any firm tool, and as soon as it touches the wet paper a line will develop of a dark density. This line will dry even darker, so bear in mind that it can't be removed because you've damaged the surface of your paper. To draw the dark tree trunk on the left in illutration E, I use the tip of a nail clipper handle over a wet wash. The sharp point of my brush handle does the thin branches, leaves, and green blades. On the right side, I get a light-line effect by squeezing the paint off the same wash when it is no longer dripping wet. For this I use a pocketknife as if spreading butter, but I press it very hard.

As you can see, line can be an essential part of watercolor. Don't be afraid of taking full advantage of it.

For the demonstration of *Wash and Line* see the color plates on pages 104–105.

23. Liquid Dyes and Colored Inks

Because of the liquidy qualities of liquid dyes and colored inks, the advantages of these chemically made pigments are transparency and brilliance. In most cases their permanence is questionable though relatively good, except for the aniline-base dyes. Before you use any of them, inquire about their qualities from the dealer or manufacturer. Artists are known to care little about the chemical properties of their material. You should be an exception; it pays many dividends.

Materials

1. One set of primary and secondary colors. It should include colored inks. I use speedball inks in my illustrations.

2. An inexpensive, children's watercolor set with *brilliant* colors. These are usually made with aniline dyes. Recently, the Japanese sets have been the least expensive and the most brilliant.

3. One set of batik dye Procion colors. You can purchase these in powder form at any craft supply house.

4. One wide flat and two smaller round, soft brushes.

5. Your favorite handmade paper.

To liquify your powdered Procion colors, which can be accomplished easily in jars, follow this recipe: to one part dye, two parts non-iodized salt, and one part washing soda, add four ounces of warm water and stir. When the solution settles you are ready to paint.

These water-soluble liquid colors are not substitutes for watercolors. They have their limitations, but their usefulness, particularly for commercial illustration, is unquestionable.

Comparing Ink and Watercolor

Colored inks, whether transparent or semi-opaque, are always brilliant. In the Value Chart on page 81 I've chosen a semi-opaque ink made by the Speedball Company. The behavior of these inks is close to transparent watercolor, as you can see. They mix well with each other, run on wet paper, dry with a slightly grainy texture, and wipe off a little when they're dry.

Mixing Browns

If you mix the three primary colors, the three secondaries, or all six combined you'll end up with three browns that are very difficult to distinguish. In the Overprint Chart A on page 81 I illustrate the overprinting qualities of these inks.

Blending Colors

A few years ago on Hawaii I had the good fortune to witness the breathtaking color display of a distant erupting volcano. My little sketch shows how well the bright reds blend with the darker, subtle blue-grays. The resulting dramatic impact is worth the fight to achieve.

Getting Maximum Transparency

Some Procion dyes are more brilliant than others, but they are all extremely transparent and fairly permanent. They are designed to stain textile materials, and consequently they behave in similarly permanent fashion on rag-content paper. I described above how you can make these dye liquids yourself; to achieve maximum transparency, use only the clear liquid on top of the settled solution. Don't stir up the sediment unless you want your wash to have a grainy quality. Overprint Chart B on page 112, shows the transparency and the overprinting qualities of these dyes. The staining power of Procion dyes is so rapid that they show a definite overprint shape (see Overprint Chart C, page 112) even if they are washed into one other when wet.

Achieving Transparency with Brilliancy

To illustrate maximum transparency with brilliance, I have prepared this sketch of a difficult subject: a bright sunset. It is impossible for these dyes to become opaque, so everything stays brilliant. To get dark definition on the scarecrow, I scrape into the wet surface with my painting knife.

In experimenting with bright and highly transparent colors, use an inexpensive watercolor set with an aniline-dye base. These colors have a strong staining power and are extremely bright. They are fugitive, however, and will fade, unlike Procion dyes. Paint with them accordingly.

For the demonstration of *Liquid Dyes and Colored Inks* see the color plates on pages 106–107.

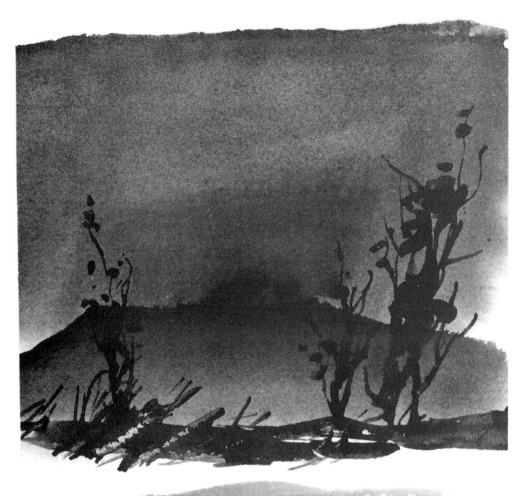

COLORED INKS

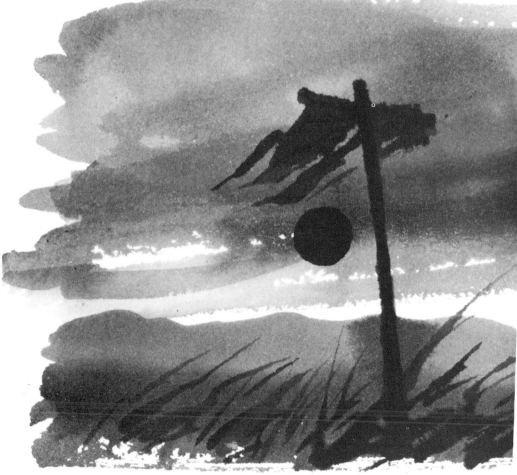

LIQUID DYES

139

24. Opaque Watercolor on Dark Paper

Just as the natural virtue of transparent watercolor is its transparency, so the natural virtue of most tempera paint is its opacity. Light opaque paint will partially cover a dark background if it is diluted; it will completely cover it if the paint is thick. For this exercise, therefore, think in terms of light tones on top of dark.

Materials

1. Some opaque watercolors. The best ones come in jars or tubes. Designers colors, made by most paint manufacturers—Pelikan, Winsor & Newton to name just two—are the same thing. Buy a jar or tube of each primary and secondary color plus white.

2. Your watercolor brushes.

3. A painting knife.

4. One sheet of black paper or board.

5. Your choice of one other dark-color paper or board.

Because a heavy layer of opaque paint can crack if bent too far, you should paint on heavy board or mounted paper.

Illustrating their Qualities

Your opaque watercolors will work in ways similar to your regular watercolors. I've prepared a few sketches to show you their essential qualities. In the first (A), I mounted three strips of dark mat board. Across the three surfaces I brushed one stroke of thick paint, one of slightly diluted paint, and a third line of thin paint. I am using white and yellow for these brushstrokes. Directly below them I apply a few strokes with my painting knife—one with a broad scraping motion, the fine ones with the edges of my knife.

Working on a Wet Board

Using a *wet* dark brown board in sketch B, I paint in light color washes. When they start to dry, I am able to give some definition to the ferns by scraping away the paint and exposing the dark background. I add the few touches of thin weeds and flowers at the end.

Painting on a Dry Mount

In my illustration C, I chose the same dark brown board again, but I used it *dry*. I make the entire sketch with my painting knife. The opaque paint is of the thinnest consistency for the clouds, a little heavier for the evergreen tree, and the thickest for the rock.

Using Two Techniques

In sketch D, I take advantage of both techniques. I brush on a pale blue wet wash for the background and then use my knife for the stark light trees.

If you work from a dark background to light values with opaque watercolor you can create a strong sense of drama. But don't turn this striking effect into a painting crutch that keeps you in a rut. To know how to achieve certain results is good. But to be a slave to one particular technique is deadly. Let common sense be your safeguard.

For the demonstration of *Opaque Watercolor on Dark Paper* see the color plates on pages 108–109.

A. THREE KINDS OF DARK MAT BOARD

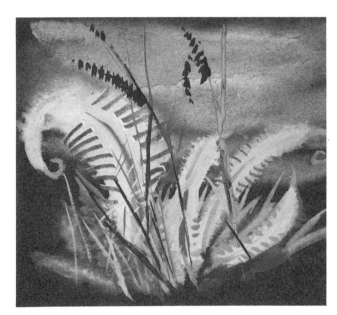

B. LIGHT WASHES ON WET BOARD

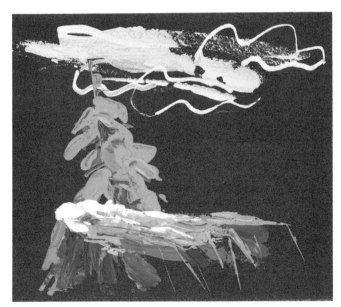

C. PAINTING KNIFE ON DRY BOARD

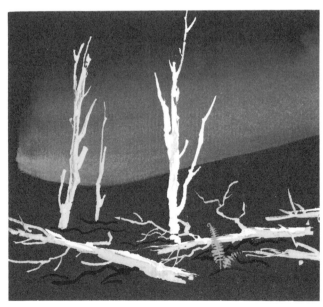

D. BOTH WET AND DRY TECHNIQUES

25. White Paint and Transparent Watercolor

When you use white paint with transparent watercolor, you're invalidating, in a sense, the nature of the watercolor medium—transparency. And there's only one reason to justify doing so. It is creativity. The most commonly used white watercolor in this technique is Chinese white, which is made to complement transparent watercolors. However, you may use any fine-grained white paint with a water base.

Materials

1. Your usual watercolors, brushes, and handmade paper.

2. A tube of Chinese white watercolor.

3. One or two other types of water-based white paints.

Softening with White

The purpose of using white paint with your watercolor is to soften the colors. You can achieve this result either by mixing the white into your color wash *before* you apply it or by painting a wash of white on top of your color wash *after* it has dried.

I've prepared a limited palette of three colors: (1) burnt sienna, (2) Winsor blue, and (3) raw sienna and two greens resulting from a combination of either sienna with the blue. (See the Limited Palette Chart A on page 112. This chart also shows the same color with a thin white wash on top of them after they're dried and as mixed into a wet wash.)

Contrasting with Warm Darks

One practical example of using a white watercolor is shown in sketch A, where I mix it into the misty background. You can see the cooling effect it has on the pigments. This cooling effect contrasts nicely with the strong, warm darks on the wood structure in the foreground. Details on the distant boats are just visible.

Covering a Dry Wash

In sketch B, I paint the same background area with just straight transparent watercolor. I paint it much darker than in sketch A in preparation for a layer of white wash to be applied on top after it has dried. For this procedure I cut a paper mask in a shape that exposes only the distant bay. Then I dip one corner of a wet, 1″ flat, soft brush into white paint and spread a thin film of it over the entire exposed background. The heavily loaded corner of the brush leaves a thicker layer of white at the bottom. After it dries this chalky wash acts as a filter, hiding many of the sharp details on the boat. I paint the two seagulls with pure white paint on a fine brush. I purposely left the wooded area unfinished in order to show you the edge of the white paint and how it differs from the value of the wash underneath.

Splattering Opaque White

You can also use white paint very effectively in another way—if you're discriminating. White in its opaque form can be splattered on top of a dry painting. In illustration C, I use a bristle brush loaded with a heavy consistency of white paint. I hold the brush about 3″ from the painted surface and flick the hair several times with my thumb. For the lower, white part of the picture, I mix a little blue into the white before I splatter again. The result is a reasonable impression of falling snow.

Let me give you another hint. Don't use opaque white extensively with transparent watercolor. Limit it to small areas—dots, lines, small shapes, and so forth. Used carefully, white should be a happy compromise between transparent and opaque watercolor and should be difficult to detect on the finished work.

For the demonstration of *White Paint and Transparent Watercolor* see the color plates on pages 110–111.

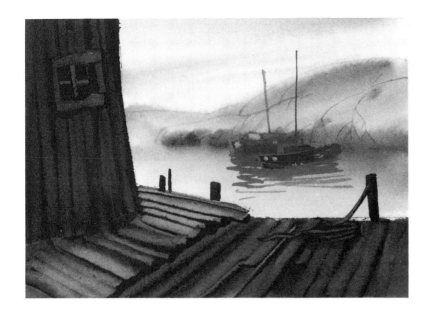

A. WHITE PAINT INTO MISTY BACKGROUND

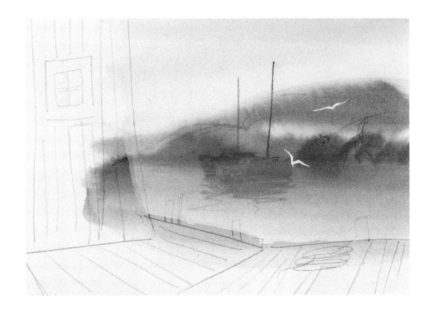

B. WHITE WASH APPLIED OVER DRY WASH

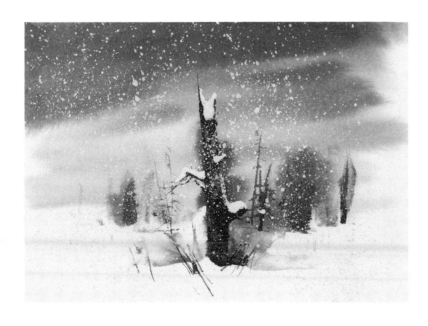

C. WHITE SPATTERING OVER DRY WASH

26. Watercolor on Prepared Canvas

Let's deal for a moment with a painfully unnatural application of watercolor. Artists are a curious group of individuals, and the unusual is almost always an irresistible challenge. This one's a real dandy for you.

Materials

1. Your transparent watercolors, brushes, and a painting knife.

2. One or two small pieces of prepared canvas, either canvas board or canvas cut and stretched from a roll.

3. One tube or jar of Chinese white or powdered starch.

4. One can of damar varnish.

5. One small bottle of mucilage (gum arabic).

You must make the surface of your canvas receptive to water. You can do this by painting on white latex wall paint, acrylic gesso, regular gesso, or ordinary laundry starch I use liquid spray starch. Powdered starch mixed with white crumbles after drying on the surface; if you use powdered starch, therefore, you must add 4 drops of gum arabic to 1 fluid ounce of starch and water.

Working on Unprepared Canvas

Just to show you what happens when you apply watercolor to canvas that has not been made receptive to water, I've made up a limited palette chart of raw sienna, Winsor blue, and burnt sienna, both clear and with white mixed into them. (See Limited Palette B on page 112.) The greens are a mixture of each brown with the blue. Note the tiny holes that showed up as the paint dried. They're caused by air bubbles trapped in the grain of the canvas as the wet brush slipped over them.

Coating with Starch

Transparent watercolor is much easier to work with on a compatible canvas base. In sketch A, I paint on a canvas board coated with powdered starch and water mixed with gum arabic. When this surface dries, you'll find watercolor easy to maneuver, but note that it will leave brushmarks as you paint similar to those you get from a thin oil wash. I've added a little crispness here with the painting knife. Don't have your paint too wet on the knife or it will run into the wash around it, just as if the surface were wet.

Using Opaque Watercolor

Opaque watercolor adheres better to canvas than does transparent watercolor, but it covers up the grain of the canvas. Presumably, the only reason you would bother to paint in watercolor on canvas is to take advantage of its texture. To use opaque watercolor on canvas, therefore, would defeat your purpose.

A limited use of opaque paint with transparent colors can, however, be an advantage. For the falling snow and for the white hump under the snow fence, I use opaque sketch B. The pale blue was flicked on with my bristle brush, but you may use an old toothbrush if you have one.

Protecting Your Surface

No matter what method you use for applying watercolor to canvas, you'll end up with a delicate surface that is very vulnerable to humidity and scratches. You must protect it. If you don't want to cover your surface with glass, spray it with a protective coat. Damar varnish is ideal, but remember that it will slightly deepen the colors. You can use acrylic sprays, too, but damar gives you the toughest finish. Whichever you chose, try it on a scrap of canvas first.

Though I've purposely limited this chapter to a discussion of watercolor on canvas, let me note that acrylic paints work much better on canvas.

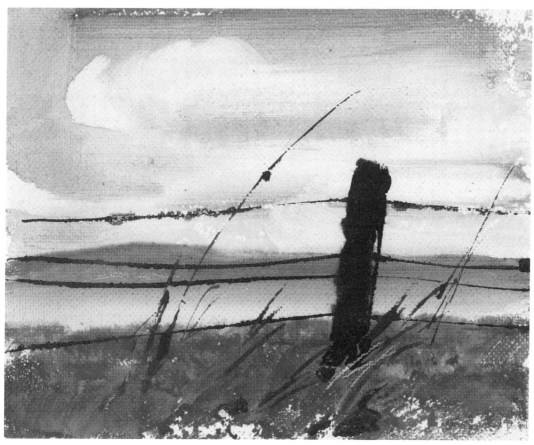

A. TRANSPARENT WATERCOLOR ON STARCH BASE

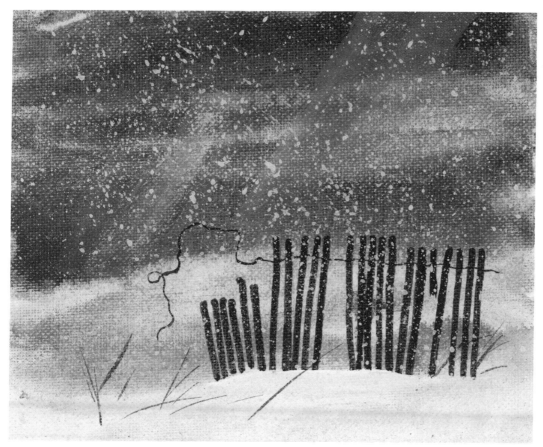

B. OPAQUE WATERCOLOR ON STARCH BASE

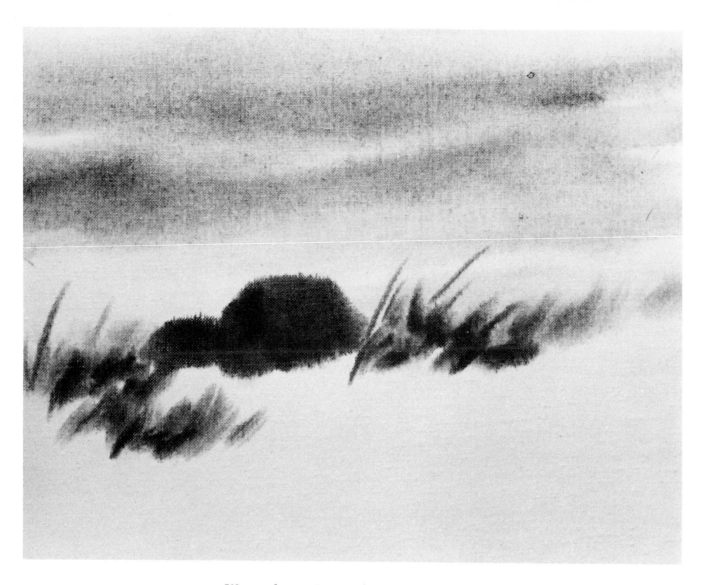

Watercolor on Prepared Canvas

Step 1. (Commercially prepared canvas board.) I wet the surface of the canvas with clear water. Using a flat, soft 1″ brush, I stroke on a soft, windswept sky. Switching to a bristle brush loaded with concentrated paint, I paint in the rocks and clumps of grass.

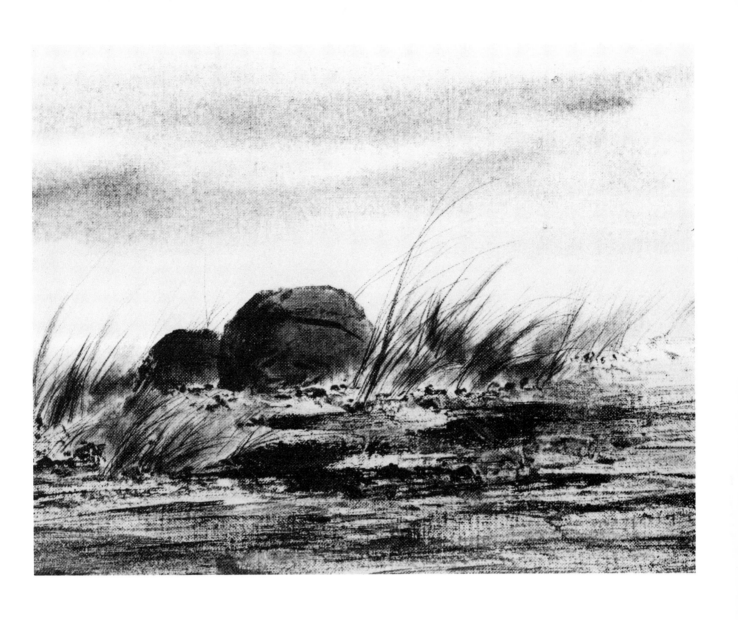

Step 2. After the surface dries, I drybrush on the pebbly foreground. I give clarity to the whole composition by adding such details as blades of grass, shadows and moss on the rocks, and scattered pebbles among the grass.

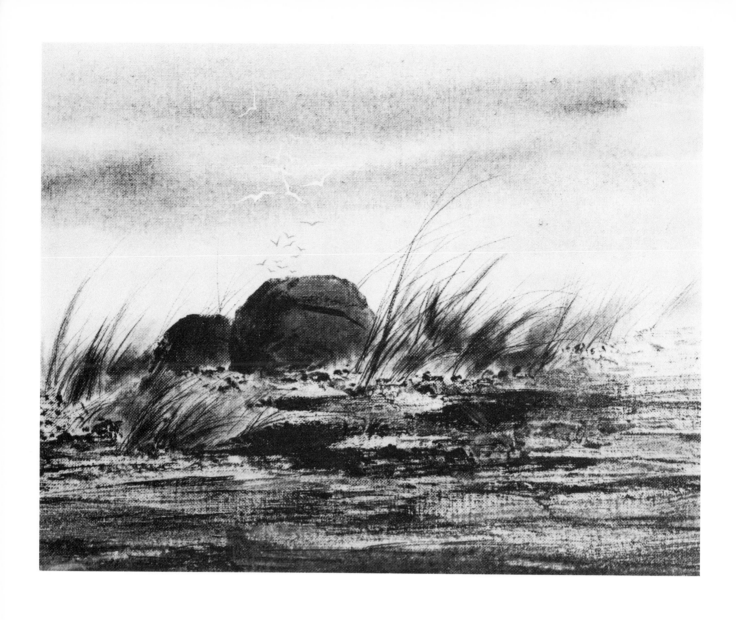

Step 3. I paint some seagulls above the rocks, using opaque white watercolor where the sky is dark and using gray watercolor where the sky is light. The gulls add vertical interest to an otherwise horizontal landscape.

27. Watercolor with Paper and Cardboard Strips

This exercise is a terrific loosener-upper. Crude tools dictate a simplified procedure. If you decide to paint unfamiliar subjects, and you feel the need of a fresh approach, try this watercolor technique—just for fun.

Materials

1. Your transparent watercolors and handmade paper.

2. One firm 1″ bristle brush to transfer heavy washes to a spacious flat surface.

3. Strips of heavy cardboard, about ¼″ to 4″ wide and long enough for you to get a good grip. The cardboard is your painting tool.

Using the Edge

Transfer your paint with a firm brush to a flat, washable surface, such as a dinner plate. Hold your cardboard firmly between your thumb and fingers. Dip the edge of your cardboard strip into the pool of color and you are ready to paint. Drag the painted edge on dry paper toward your thumb, pressing firmly but evenly. This scraping action will give you a thin wash, straight at the starting point, but turning irregular as the board loses paint. You can create a straight line by just touching the paper with the freshly dipped edge of your painting strip. The corner will serve as a simple line-drawing point. For sketch A, I use one 2″, one ½″, and one ⅛″ strip of mat board.

Working on a Dry Surface

For my next illustration I use cold-pressed paper with a dry surface (B). I lay a wide strip of ordinary writing paper into a pool of paint, lift it onto my painting surface, and press it down gently with my fingers. Note the sky texture the paper creates. For the boats, water, and boardwalk, I use cardboard strips. The masts are painted with the edges of my cardboard.

Scraping for Values

When you transfer paint with your cardboard strips to wet paper it will spread and flow as if you had used a

A. DRY PAINTING EDGE ON DRY PAPER

B. WET PAINTING EDGE ON DRY PAPER

brush. In sketch C, I am using both a wet and dry surface—wet for the background and dry for the lines in the foreground. I scrape off part of the dark wash on the banana leaves while the paint is very damp; in this way I am able to achieve the light values on the leaves. The scraping technique works best with staining colors.

Adding Details

In my last illustration, I start with wet paper, adding details as the paper dries (D). I use the corner point of a strip of cardboard to draw in the swaying palm branches and the birds.

Try many types of paper and cardboard and with a variety of cut and torn edges. You'll find this technique sharpens your power of concentration.

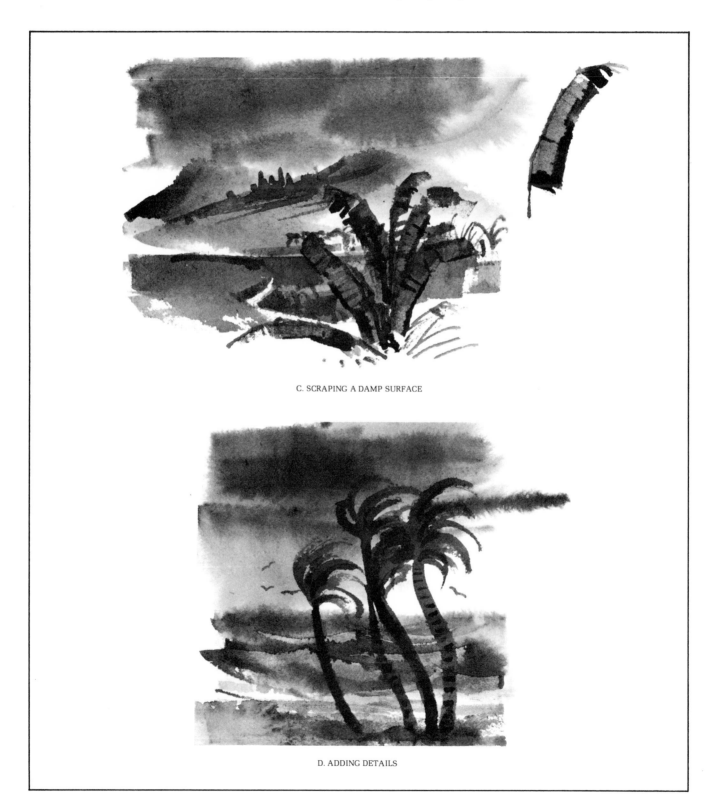

C. SCRAPING A DAMP SURFACE

D. ADDING DETAILS

Watercolor with Paper and Cardboard Strips

Step 1. (300 lb. D'Arche's cold-pressed handmade paper.) I cut up several scrap pieces of mat board. After dipping one board into a pre-mixed pool of watercolor, I use the board's edge to sketch the dry weeds in the foreground. I use the same method to outline the trees in the distant forest, smearing the edge slightly to create the vague blue shadows between the trunks.

Step 2. Next, I outline the larger birch in the foreground, using another, smaller scrap of board to paint the peeling bark and other details on the trunk.

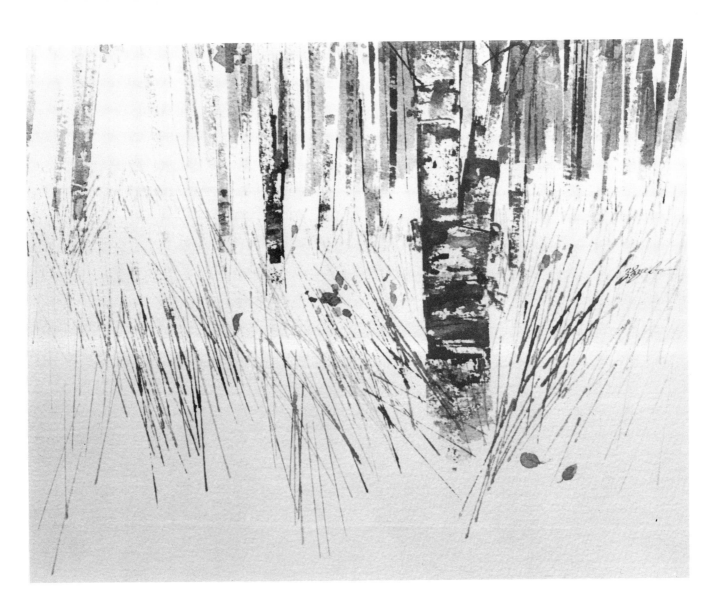

Step 3. I break up the sharp horizontal division in the composition by adding trees and weeds to the middleground. Carefully controlling the corner of a new scrap of board, I paint in the scattered leaves and the hint of yellow foliage still left on the trees.

153

28. Watercolor with Rollers and Squeegee

The use of rollers with watercolor is also fun. They'll further demonstrate the versatility of the medium, too. Moreover, rollers will polish your sense of design because of the bold simplicity they offer. You can't get bogged down with details. The limitations of the tools won't let you. Your *design* must carry the composition.

Materials

1. Your watercolors.

2. One firm 1″ brush.

3. Handmade paper.

4. A 3″ hard plastic or wooden burnishing roller.

5. One soft, narrow wall-paint corner roller.

6. One rubber squeegee about 6″ wide.

Testing the Soft Roller

Make a few impressions with your new painting tools to find out what they'll do. Let's start with the rollers. If you press lightly on the soft, fluffy corner roller, it will make an impression on the surface of your paper very much like a sponge (A). Press harder and you'll have what looks like a wash with an irregular, rough edge. The variation and repetition of these roller marks on dry or wet paper will give you a good number of texture combinations.

Conditioning the Hard Roller

Before you can use a burnishing (hard) roller for painting, you must condition it. The usually smooth wood or plastic surface will repel water, so rub it with fine sandpaper until the glossy finish turns dull. Now you're ready to test it. With the help of your firm 1″ bristle brush, make a pool of watercolor on a large, flat surface. You must have enough room to move the roller freely back and forth. Now bathe the roller in the paint until the entire surface is covered (B). Roll the edge on your paper in a straight line and then curve it a little. When your roller runs out of paint, pick up

more and you're ready to go again. Next try a rectangular wash by rolling and pressing the cylinder on its broad side. If you just touch the broad side of the roller it will leave a heavy swath.

Using Both Rollers

I have painted sketch C using both rollers. The sky is done with broad sweeps of the hard roller, and for the texture of the weeds I use the soft corner roller. The sharp edge of the hard roller is made use of to indicate the wires and thin weeds over the dark fence posts.

Varying the Pressure

For illustration D the hard roller only is employed. The paper is dry. For the sky I apply gentle pressure to get the texture. In the lower area I press hard to obtain a solid coverage of light blue. Into this wet wash I roll the light brown and let it blend with the blue. After these washes dry, I roll on the dark linear definition, including the birds, with the sharp edge of the roller.

Painting with a Squeegee

For a rubber squeegee you can use the edge of your windshield wiper or a silk-screen squeegee. Dip your squeegee into a pool of watercolor and make an impression on your paper by pressing and pulling the edge in the same direction several times, partly overlapping the strokes (E). You can make fine, straight lines with the edge of the rubber blade. And you can gain variation if you make one stroke in one direction and a second stroke crossing over the first.

Removing Surplus Paint

I have painted the small sketch F with a rubber squeegee. It shows all these strokes. Pressure on the rubber edge removes the surplus paint at the top edge of the water to show a distant horizon line under the distant round hills. I've drawn the bird with the corner of the rubber blade.

A. CORNER ROLLER

B. HARD ROLLER

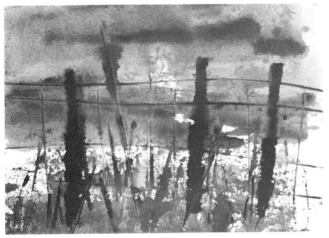

C. CORNER AND HARD ROLLERS

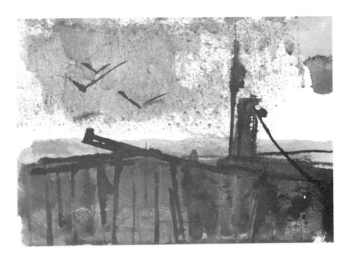

D. HARD ROLLER DESIGN

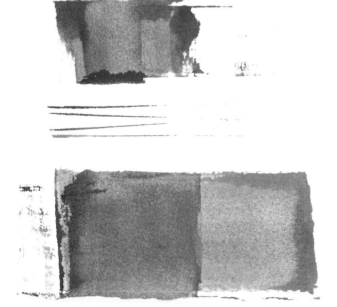

E. SQUEEGEE

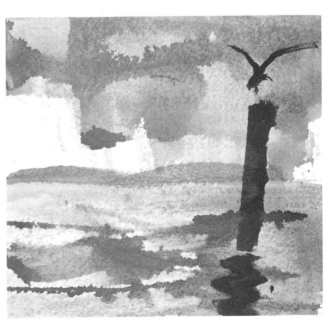

F. SQUEEGEE DESIGN

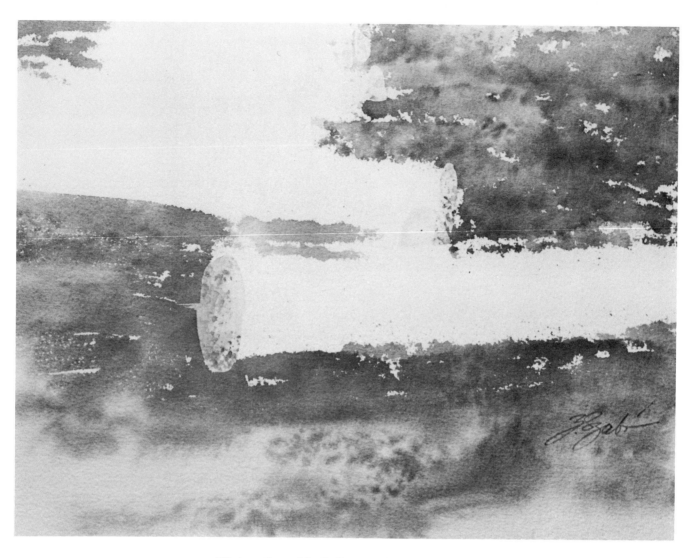

Watercolor with Rollers and Squeegee

Step 1. (300 lb. D'Arche's cold-pressed handmade paper.) Using liquid latex, I mask out the ends of the logs. After it dries, I wet the bottom edge of the paper and use a soft roller to spread on the base washes for the scruffy grass.

156

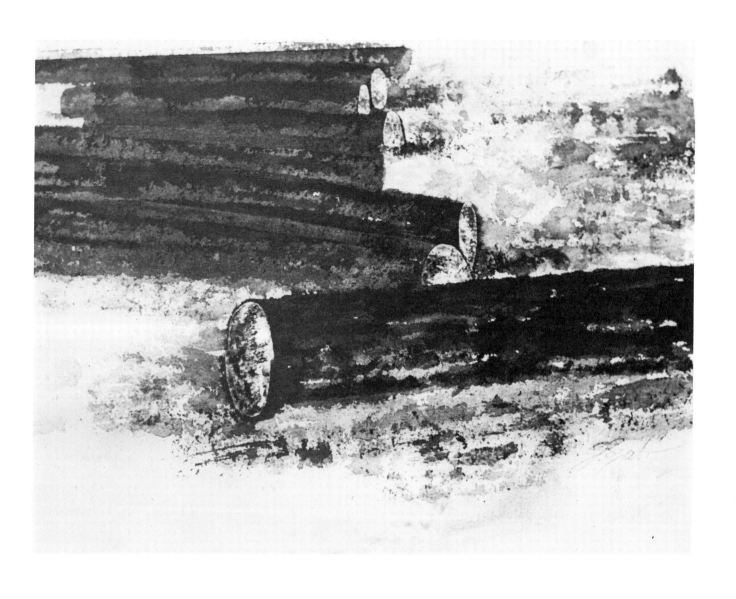

Step 2. After Step 1 dries, I use the same soft roller to establish the dark bark of the logs and to add definition to the grass.

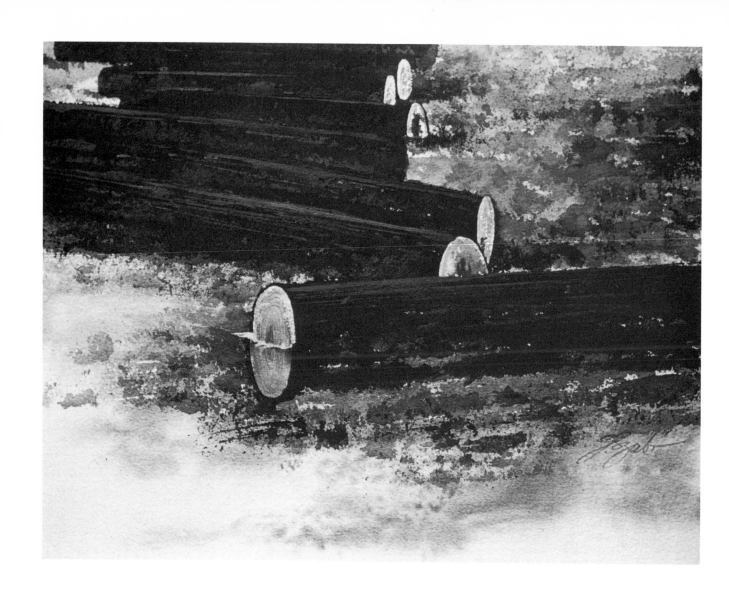

Step 3. After removing the latex masks, I paint the exposed ends pale orange. Using the corner of a rubber squeegee and light brown opaque watercolor, I outline the growth rings on the ends and the bark on the trunks. These details add crispness to the whole composition.

29. Using Oil Paint Washes as Watercolor

One of the most practical reasons for a watercolor painter to reach for his oil paint is cold weather. Painting with oils diluted with turpentine is similar to painting with watercolor. Their advantage is that you can paint with them on location in sub-zero weather—when your watercolor will freeze if you don't.

Materials

1. Small tubes of oil paints: cadmium yellow pale, raw sienna, burnt sienna, Prussian blue, and titanium white are sufficient.

2. Two firm nylon brushes. Those made for acrylic are particularly suitable.

3. One 2″ wide wetting brush.

4. Two sheets of high-quality rag paper. The same kind you use for watercolor is fine.

5. A bottle of turpentine and a small cup to hold it in.

6. One mixing palette.

7. A roll of toilet tissue.

For experimenting—and painting—with oil washes, you can use the thinnest paper available because turpentine, unlike water, won't cause the paper to buckle. Like water, however, turpentine is transparent and colorless, and it will dry just as completely. Though it dries as fast as water to the touch, turpentine takes about a day to become altogether dry. It doesn't matter what type of brush you use with oil and turpentine as long as the oil paint is well diluted to resemble a pool of watercolor wash. Don't leave chunks of thick, undissolved paint on your brush.

Experimenting for Values

Now try a little painting experiment on dry paper. Keep the paint fresh and free flowing. In my sketch A, I have painted a simple design to show you how light and how dark your values can be with thin, dissolved oil washes. The better your quality of paint, the more transparent your washes will stay because the pigments are ground finer.

A. OIL WASHES

Using a Turpentine Wash

For the next exercise, brush your painting surface with a rich wash of turpentine until it looks wet. If you paint into this surface with a soft brush you'll get a slight spreading effect—as in the sky of sketch B. For my illustration, I splatter clean water on the dry paper first. I let it soak in for a couple of minutes while I get my blue-gray oil-and-turpentine wash ready. With a tissue I blot up the surplus water beads and immediately slap on first a wash of turpentine and then my oil-and-turpentine dark color. Where the water spots remain, the turpentine wash is repelled. This procedure must be executed very quickly, while the surface of the dampened spots is still wet enough to reject the oily wash.

After the first wet wash, I paint the rest of the softer details with a smaller brush. As the paper is drying I add more of the finer details. I paint the little weeds last with a small, soft-haired brush.

Working on Dry Paper

For a better illustration of the water-masking technique, I've waterbrushed the shape of the sign and the post (C). For a clearer result, I do not paint on a clear

turpentine wash. Instead, I apply the blue oil-turpentine wash directly to the dry paper after blotting up the surplus water. The shape of the sign and post survives almost pure white. Later I paint the warm brown color on the sign to make it look like wood. The drybrush strokes hinting about a blizzard are next and the little weeds last.

Painting Light on Dark

If you're careful you can paint a light color on top of a dark wash (D). You can do this by mixing your light color just a little thicker than you did for the wash and by applying it when the paper is no longer dripping wet. You can use a soft brush because the paint should still be thin enough for easy handling.

One more characteristic of the oil-turpentine wash technique is that your colors, unlike watercolor, do not dry darker. They'll keep their value. The only exception to this rule occurs when you paint thin light washes on top of dark. A little practice with oil paint washes will tell you a great deal about the nature of this exciting technique.

B. OIL-AND-TURPENTINE WASH

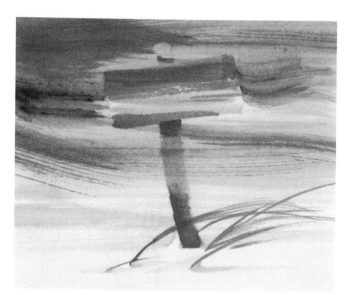

C. WATER-MASKING

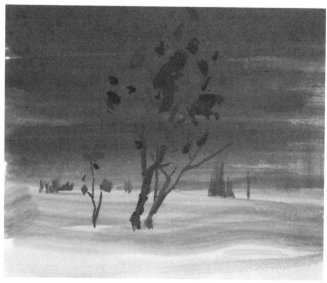

D. LIGHT COLOR ON DARK WASH

Using Oil Paint Washes as Watercolor

Step 1. (High-quality watercolor paper.) I soak the paper with turpentine. Using a bristle brush, I stroke in a background of soft, undefined vegetation. I paint my focal point, the spruce branch, and add some colorful dry leaves on the ground.

Step 2. As the paper starts to dry, I add further details such as more leaves and the woody spine of the spruce branch.

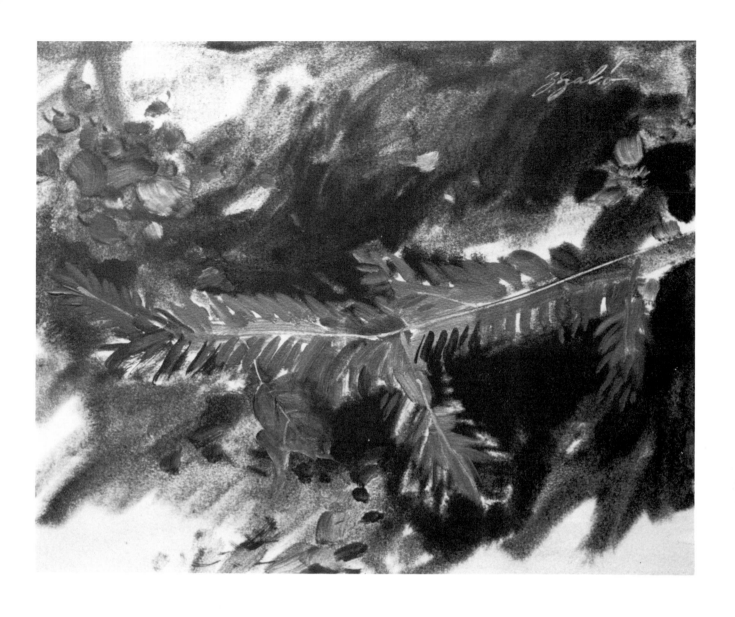

Step 3. For a finishing touch, I paint the fallen red leaf caught in the branch.

30. Watercolor on Plaster

Plaster has a porous, smooth-textured surface—ideal for water-based paints. The result, achieved from applying watercolor to plaster, can easily resemble a genuine fresco. I want to explain the watercolor-on-plaster technique to you in case you ever have the opportunity—a challenging one—to work on a wall surface.

Materials (for practice)

1. Your usual watercolors and brushes.

2. A ¼″ piece of 12″ x 16″ Masonite or any other board with a coarse surface.

3. About 2 lbs. of plaster of paris. To paint on a plaster wall you must prepare your colors in volume. For this the best materials are dry pigments for color and casein painting medium for a binder.

Preparing Your Surface

Because your watercolors behave so differently on plaster, you should prepare yourself a small surface to practice on. This is how I do it: I pick a piece of ¼″ Masonite board and place it on a table with the reverse (coarse) side up. I make a crude receptacle of mat-board pieces and tape them to the Masonite with double-sided masking tape, leaving a center section exposed (A). I then mix a cup of plaster runny enough to pour into the center space surrounded by the mat board. I let the liquid plaster flow naturally to the edges. You could use a wide squeegee to flatten the surface completely. I choose to leave it uneven.

Simulating a Wall

I let the plaster set and dry overnight. The next day I remove the cardboard and my plaster surface is ready to paint on (B). It is as thick as the mat boards that had surrounded it. The thickness is unimportant as long as you have enough body to the plaster to simulate a wall surface.

Applying Strokes Quickly

I am now ready to proceed with my painting. I use my regular transparent watercolors and soft brushes with good points. Because the watercolor soaks into the porous plaster immediately, I apply each brushstroke very quickly (C). For the white snow on the branches, I scrape off the painted plaster with a pocketknife blade after the paint is dry.

Adding a Few Hints

I would like to add a few general hints about the watercolor-on-plaster technique. Because the water is soaked into the plaster as soon as it hits it, you can't blend colors together on the surface so don't try. Each brushstroke survives as it touches the plaster surface.

Colors lose a lot of their strength because much of the pigment is quickly absorbed below the surface. You can check how deeply the pigment seeps in by scraping off the surface. You'll have to remove three layers or so of plaster before it will be white.

If you paint on a wall surface that is now new, wash it down with a vinegar solution (⅓ vinegar, ⅔ water). The solution will remove any grease from the plaster.

Using Casein Tempera

To maintain a consistent painting quality on large walls, and for economic reasons, you should use casein tempera. You can mix your paint in jars or as you advance with the painting. Buy pure pigments (colors) in jars and mix them with prepared casein painting medium. This casein tempera mixture will behave very much like transparent watercolor when you apply it, but the colors will have a greater tendency to stay on the surface and you'll find they'll survive better.

A. PREPARING THE PLASTER

B. YOUR PLASTER "WALL" READY FOR PAINTING

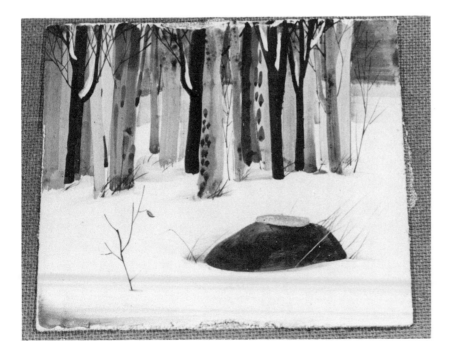

C. PAINTING ON PLASTER

Watercolor on Plaster

Step 1. (A slab of plaster with a coarse surface.) Using a soft 1″ brush, I establish the basic texture of weatherbeaten wood. Because the paint soaks in very fast, I slap on each drybrush stroke very rapidly.

Step 2. I add more detail to the wood grain and paint the axe marks as well as the large cracks on the old wood.

Step 3. I scrape off the wood texture where I intend to put the rusty nail. In the exposed white space, I paint the nail and then add its shadow right on top of the nearby wood texture. The result is quite believable.

Bibliography

Blake, Wendon. *Acrylic Watercolor Painting*. New York: Watson-Guptill, 1970.

———.*Complete Guide to Acrylic Painting*. New York: Watson-Guptill, 1971.

Brandt, Rex. *Watercolor Technique*, 6th ed., revised. New York: Reinhold, 1963.

———.*The Winning Ways of Watercolor*. New York: Reinhold, 1973.

Guptill, Arthur, edited by Susan E. Meyer. *Watercolor Painting Step-by-Step*. New York: Watson-Guptill, 1967.

Kautzky, Ted. *Painting Trees and Landscape in Watercolor*. New York: Reinhold, 1952.

———.*Ways with Watercolor*, 2nd ed. New York: Reinhold, 1963.

Kent, Norman, edited by Susan E. Meyer. *100 Watercolor Techniques*. New York: Watson-Guptill, 1968.

O'Hara, Eliot. *Watercolor with O'Hara*. New York: Putnam, 1966.

Pellew, John C. *Painting in Watercolor*. New York: Watson-Guptill, 1970.

Pike, John. *Watercolor*. New York: Watson-Guptill, 1973.

Reid, Charles. *Figure Painting in Watercolor*. New York: Watson-Guptill, 1972.

———.*Portrait Painting in Watercolor*. New York: Watson-Guptill, 1973.

Schmalz, Carl. *Watercolor Lessons from Eliot O'Hara*. New York: Watson-Guptill, 1974.

Whitney, Edgar A. *Complete Guide to Watercolor Painting*. New York: Watson-Guptill, 1965.

Index

Edited by Claire Hardiman
Designed by Robert Fillie
Printed and bound by Halliday Lithograph Corporation
Color printed by Sterling Lithograph